PAPARAZZI!

MICHELLE LECLECH

PAPARAZZI!

ISBN: 978-0-692-17242-1

Third Edition

TABLE OF CONTENTS

Ancedotes of the "Stars"

Helen Hayes: After I snapped about 15 photos of Helen, her friends, and the two of us together, Helen asked in a perturbed tone, "Who is that WOMAN?" At that moment, a stagehand pranced across the stage and chimed, "She's the Paparazzi!"

Vincent Price: When asked if I could take a photo of us together, Vincent held out his hand and said "Sure! But it will cost you a dollar!"

Henny Youngman: He couldn't understand why I was shooting so many photos of him and confusedly asked me, "What are you, some kind of NUT or something!?" I replied, "Yeah. Cashew. What are you?" Smirk.

Jason Robards: Jason remarked, "Gee, these things are cheap! That's how much they think of us," as he held the Helen Hayes Award trophy in his hands backstage before the ceremony. Suddenly, the "HH" centerpiece on the trophy fell off and rolled across the floor. It was hysterical.

Peter Jennings: (Before entering a party.) Peter asked me, "What are they wearing in there?

"Mostly tuxedos."

"Oh no!"

"Don't worry," I said, "people are used to seeing you in a regular suit as a news person." He was still worried, but calmed down after I reassured him that he wouldn't look out of place. (He was really nice and oh-so-handsome.)

President Aquino: At a women's club meeting in Washington, D.C., I

tried to shake her hand, but a secret service agent grabbed my hand and told me I should not do that. When he looked the other way, I smiled at her, shook her hand, and said, "Nice to meet you!" She returned the smile and said, "Nice to meet you too!" (What a tiresome man, trying to spoil my fun like that.)

Kareem Abdul Jabbar: "My name is not LOU!" he snapped at me in the airport one day when I forgot his Muslim name. I thought, well, if it upsets him so much, why is he silly enough to respond to it?

Introduction

WHEN I WAS 13, I was a big Beatles' fan and started to collect record albums from most of the popular English groups at that time. As I grew to be 14 and 15 years old, I wanted to go to concerts but couldn't afford it, so the best I could do for excitement was to hang out around stage doors at the arena or coliseum and hope for some photos and autographs of the groups, who most of the time obliged. It was exciting to see them in person and it gave me something to talk about to the girls in the neighborhood.

Another big influence on my celebrity-tracking hobby was my mother. She worked at a downtown Seattle restaurant in the 60's and whenever English rock groups would come in to eat she'd get their autographs for me. To this day I don't know what I did with them, but it was fun at the time just collecting them. The autographs I have today are from John Wayne, (worth $300 so far), former President Bush, Sr., former President Ronald Reagan, former President Bill Clinton, Tip O'Neill, Bob Hope, Martin Sheen, Rudolph Nureyov, Whoopie Goldberg, Muhammed Ali, Ken Griffey, Jr., and Ichiro.

In 1987, I was searching for a government secretarial job and was blessed with an opportunity to interview with Bob Hickey (a dead ringer for Paul Newman!). Of course, I fantasized about working for a celebrity look alike, and the guy hired me the next day. None of my friends could believe his resemblance to Paul Newman and he "wowed" them all. I stayed at the job for three years. I don't know if it was his great personality or his "movie star looks" that kept me employed. I soon wasn't interested in autographs anymore, photos were more intriguing to me and made for fabulous conversations. I had never been a great conversationalist, but after traveling around Europe, Canada, and the United States, I had something to talk about

in social circles – and then I had my celebrity photos and how I managed to get them.

I remember when the Kinks were in town in1965. I found out where they were staying and hopped a bus to downtown. I found them eating breakfast in a café. I walked up to Mick Avery, the drummer, and asked if I could sit and chat with him. He invited me to sit and told me that he was free to sight see. I decided to give him a tour of the main downtown area where the interesting stores and shops were located. At one point, we passed by Woolworth's, so I dragged him inside where we crowded into a photo booth together. For 25 cents, I got a photograph of myself and the drummer of the Kinks!

Over the years, I've created a collection of about 400 photographs of celebrities, sports personalities, and politicians. Some of the best photographs are the candid shots because they capture celebrities who seem larger than life in a more human light. My subjects aren't always thrilled with those shots; Bob Hope and Ted Kennedy, Sr., in particular, have given me many perturbed expressions that I've captured on film. That's why the candid shots are far more interesting to me. I usually take as many photos as possible, regardless of what my subjects are doing, because I don't know if I'll ever see them again. I've captured a very serious Jessica Lange in a photo, and Sylvester Stallone once angrily shook his table number at me after I took about 30 photos of him and Bridgette Nielson (then his wife). He said, "Hey, Dats enough!" I've preserved that treasured moment on film, too. Great photo.

When I moved back to Washington, D.C. in 1984, I learned where all the gala events and fundraisers were being held every week. I would hear rumors at the office or read the paper to find out the locations, but the typical hot spots included the Marriott, the Hilton, the Sheraton, the Shorham hotels, the Kennedy Center, and the Embas-

sies. Since I was not on the guest list for any of the events I wanted to attend, I needed to find ways of "crashing" the parties. Sometimes I grabbed an empty glass that a guest left on a table in the lobby, go into the restroom to fill it up with water, and then go to the entrance with the glass in hand acting as though I had just stepped out for fresh air. Other times I'd hang my official government ID badge (which everyone who worked for the government in D.C. had) around my neck to give the appearance of a press pass.

The most important things to remember when party crashing is appearance and attitude. I would normally dress up in lovely evening attire, and if my closet didn't supply the perfect dress, I would borrow something from a friend. Once on the scene, I would stare the security personnel directly in the eye, appear serious and professional, and say, "Hi" or "I'm looking for Bob." Bob is a great name to use because it is so common and there is almost always someone named "Bob" operating something at most functions, believe it or not. Other times I would say that I had to deliver a package or had to tell someone something quickly (that got me through many times). Sometimes I'd say I left my camera equipment backstage and had to pick it up immediately. They would usually let me through, as long as I looked confident and exuded an air of belonging.

I would also familiarize myself with the buildings hosting the events. (Knowledge of the floor plan is essential for confidence.) I hunted for all of the back entrances and stage doors at the popular places to facilitate my "uninvited" party access. If anyone asked me, I would tell them that I was a freelance photographer for a local paper. Once I got in, no one usually asked me anything else, so I'd pull up a seat, eat the filet mignon dinners, drink the wine along with other guests and enjoy the speaker, or show, or whatever the event was. In addition to never having to eat dinner at home, I feasted on the finest

gourmet foods with celebrities and powerful government officials, and then, at the end of the evening I could go home with an incredible floral arrangement taken straight from the table! Not to mention the photos I would keep for a lifetime.

People who know about my adventurous hobby have been suggesting to me for years that I compile the stories from the parties I've crashed. I never slowed down to really concentrate and do it, until now. I find myself getting an adrenaline rush as I write each story. As I reminisce and put myself at the scene of each affair again in my mind, I actually get excited all over again.

When Alex Haley passed away, it reminded me of the time I met him walking down the street in the 1970s. In Washington, D.C., "Roots" had just been shown on TV and Alex was coming from a meeting or something. I recognized him right away, got excited, and walked up to him. I said, "Hi, Mr. Haley!" He said, "Hi. Who are you?" I told him my name and that I was from Seattle, but I was working in D.C. temporarily. He said he'd been to Seattle before and liked it. I got his autograph, but no photo since I didn't have my camera. I walked up to a woman at the bus stop and asked excitedly, "Do you know who that was?" She said she didn't. I said, "That's Alex Haley, the author of 'Roots'!" She said, "Frankly, my dear, that kind of thing doesn't turn me on." I jumped back at her snootiness and walked away. What a kill joy, I thought to myself. How can you not get excited over "brushes with fame!?"

When he was little, I even had my son, D.J., in on the act. He tagged along with me to functions in Seattle and now has photos of himself on Jane Fonda's lap at the 1990 Goodwill Games, and, with Mickey Rooney, Quincy Jones, Ken Griffey, Jr., Danny Glover and Nelson Mandela.

My friend Charmaine knew how much I liked to photograph ce-

lebrities. She also liked to remind me how I got carried away with film and processing expenses to the point where they would come before my most important bills. It was an addiction, although I never realized it at the time. When I ran out of money for food, she'd say, "Well, Michelle, now you can just eat those pictures." I'd laugh, but she was trying to tell me something.

In addition to the autographs, I've received letters from Mrs. Reagan, Geraldine Ferraro, Mrs. Mondale, Senator Ted Kennedy, and Jimmy Carter, and birthday cards from three presidents. Oh yes, I have lots of autographs I'd sell for the right price to anyone interested. As I mentioned earlier, I don't care about them anymore.

As Pepper Schwartz, a University of Washington Psychologist and commentator for KIRO radio in Seattle, theorized, "Michelle just has a compulsion when it comes to chasing the stars – it's benign. She's not out to hurt or harass anyone, she wants her photos." It's true. You know how the song goes "Girls just wanna have fun!" I say.

CH. 1 - VICTORY OF THE SPIRIT AWARDS
(1985, Washington, D.C.)

A GRAND AFFAIR WAS ABOUT TO TAKE PLACE at the Kennedy Center one night, so I decided to go check it out. I walked in the main front entrance as I usually did, but I noticed a man go through a back door as I entered the lobby, so I followed him to see where it led. Lo and behold, it was backstage. As I got my camera ready to shoot any celebrity I might see, people were scurrying here and there trying to get ready one hour before the show, so I walked along the back corridor.

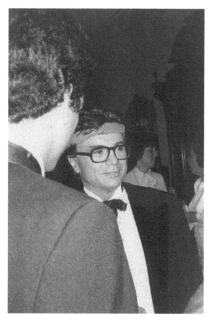

Robert Blake, "Baretta"

Suddenly, I came across the doors to the dressing rooms. Liz Taylor, Robert Guillaume,and,Teddy Pendergrass. As I looked behind me I saw two people talking, and to my amazement, one of them was Ted Kennedy, Jr.! Wow, was he ever handsome. I just flipped. I had no idea who was a part of this show, but I was to find out soon.

I asked the lady standing behind me if she'd mind taking a photo of Ted and I and she said, "Sure." So, after he finished talking with the woman, I asked if I could have a quick photo of him for my collection. He said "sure" and smiled as he put his arm around me and I put my hand on his chest. I was so excited! He looked just like his father.

(I always tried to cuddle up to my celebs by touching their hands or hugging them - as you'll notice in all my photos because it makes

them more personal to me.)

After we took the photo, I thanked him and walked among the stagehands and make up crew in search of more politicians and celebrities. I came upon Robert Blake (of Baretta) talking to Kathryn Helman (of Soap and Who's the Boss?), so I wandered to the make up area to get a closer look. I asked them to pose for me. They did graciously, and then I asked Robert Blake to take a few poses with me alone. He was funny and really hyper. He kept saying witty things and ran around socializing backstage. I have one photo of us kissing and one with us smiling cheek to cheek.

Then I noticed Ed Asner (of Lou Grant) getting his face made up for the TV cameras by a woman who did make up for a lot of the celebrities. She was so beautiful she could have been a star herself. I asked Robert Blake to go and stand by Ed Asner and let me take one more photo. He said, "Okay. But wait, let me do this..." and he

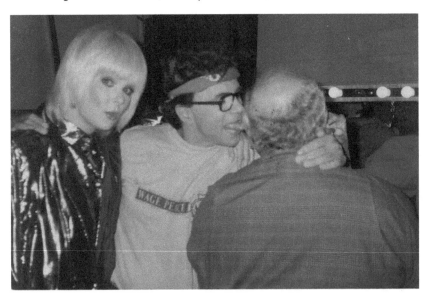

Ann Jillian looks on surprised as Robert Blake gives Ed Asner a "Hollywood greeting" while he gets his makeup put on.

proceeded to stick his tongue into Ed Asner's ear. It's one of the funniest photos I have ever taken. Washingtonian Magazine (in D.C.) bought that one from me for $75.00 and labeled it "Lou Grant gets Hollywood greeting from Baretta." Even though Ed Asner had the back of his head to the camera as I clicked, you could see reflected in the mirror in front of him the expression of contentment that was on his face (like a cat getting stroked). One advantage of my vice is I got to see that movie stars can really be fun and crazy, just like the rest of us common folk.

After the frolicking engagement, I stumbled onto Robert Guillaume's room and knocked on the door. He said, "Come in," I poked my head in and asked if I could take a quick photo of him. He replied, "I guess so. Can I put my shirt on?" "Of course," I said. He then asked what he should do, and I said, "Strip! . . . No, just kidding. I just want

you to stand there and smile." He did. He was pretty cool. (I saw him again months later at Sugar Ray Leonard's birthday party.)

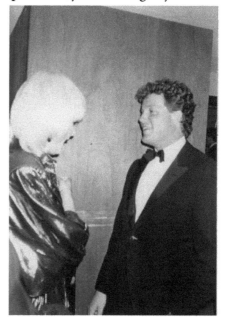

As it came closer to show time, Robert Blake was still playing around backstage. But when the stagehands warned that there was only five minutes to show time, he began darting around asked frantically, "Where is my dressing room? Where's my damn dressing room?!" There were so many dressing rooms that he forgot which hallway

*Ann Jillian greeting
Ted Kennedy Jr. backstage.*

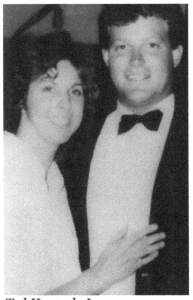

Ted Kennedy Jr.

contained his. He wasn't fully dressed and had wasted his time by chatting with the other stars before the show started. Somehow he got ready. He chose to wear an old fashioned jacket and a flamboyant red tie. The promoters seemed angry because he refused to wear a tuxedo like the rest of the male stars. But, he's always been a rebel. He likes to be different. And, I thought I was a hyper person, but Baretta beats me! He wore me out just watching him run around.

Then, Ann Jillian and Lynda Carter showed up, and I asked Ted Kennedy Jr. if he wanted a photo with them. He said, "Really? You'll take one and send it to me?" I said, "Sure." So I asked the girls to go over and stand by him, and they each kissed him on the cheek. He blushed something terrible. He loved it. I later sent those photos to his dad who forwarded them to him in Massachusetts. I actually did get a thank you note. It read: "Thanks for the photos of my son, Lynda and Ann—he loved them! Ted."

As the show was about to begin, I walked down a side hallway and found that the auditorium was almost full. I managed to find a seat in the seventh row hoping not to get uprooted by someone with a ticket (as I have in the past – only to go sit in another seat). (At one function, I had to move five times, but I just acted as if I were floating around to observe. I never acted embarrassed when someone asked me to get up. I would smile, say "excuse me" and then go find

another seat.)

Soon thereafter, Ted Kennedy Sr. arrived and sat right in front of me – alone. As Ted Kennedy Jr. got up on stage to be awarded a trophy for his life achievements in overcoming a handicap, his father rose to go backstage to congratulate him.

Robert Guilluame, Robert Blake &
Ted Kennedy Jr.

I thought about following him to steal a shot of them together holding the award, but I had taken so many photos earlier that I decided to leave them alone for a while. I behaved myself for the rest of the night. It was quite an affair.

Lynda Carter and the author.

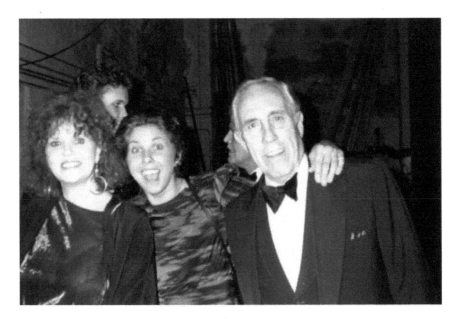

Eileen Brennan, the author & Jason Robards.

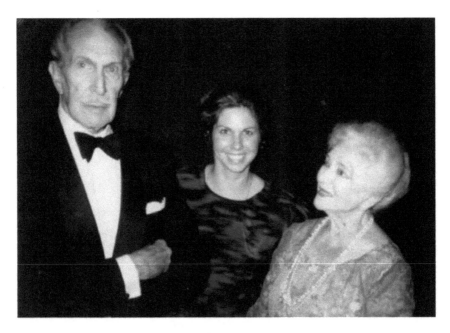

Vincent Price, the author & Helen Hayes.

CH. 2 - HELEN HAYES AWARDS – NATIONAL THEATER

IT WAS AN EARLY SATURDAY EVENING and I got off the bus and walked toward the side door of the National Theater where all of the stage-hands and entertainers enter. The guests hadn't arrived yet but most of the Hollywood movie stars were already in the backstage door. A lady came out and said "Can I help you?" I said "Yes, I'm looking for Bob." She said "Bob who?" I said "Johnson." She said "I don't know him but he may be in the auditorium; you can go look if you like." I said "Thank you" and went through the curtain and looked around. Everyone was walking around quickly trying to get things ready for the guests. As I entered another hallway I saw Helen Hayes and her beau. She was dressed in a beautiful sequined white dress. I got my camera out and took some photos of them, then asked a person standing behind me to take one of Helen and me. She said "O.K." and Helen agreed to let her take a photo of us together. Then I moved on and saw Vincent Price talking to some people and I walked up to him and asked if I could take a photo with him and he jokingly said "Sure!, but it will cost you a dollar, my dear" as he extended the palm of his hand. I laughed and said "O.K." And he grabbed me and hugged me while a stagehand took our photo. Then a few moments later he was standing with Helen Hayes and I took photos of the two of them to-gether and I jumped in

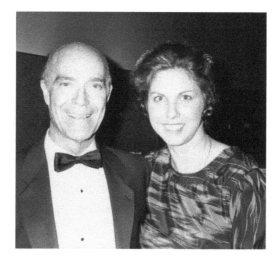

Keene Curtis.

19

between the two for a shot of the three of us.

By then I had probably taken ten or more photos of her and she finally blurted out surprisingly, "who is that woman?" and a stagehand pranced across the stage area and said "she's the Paparazzi!" and they all laughed. I thanked them again for the photo session and walked to another corner of the stage area. Then I saw Jose Quintero, Jason

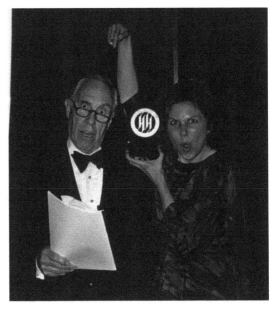

Jason Robards & the author clowning around backstage.

Robards, and Keene Curtis. I took some candid photos of them all standing around talking and then I got the funniest photo of all my adventures: Jason Robards was getting ready to open the curtain a little to peek at the crowd in the auditorium but instead of opening the curtain from eye level to peek, he started to open it from his belt level and I snapped the photo at that moment and it looked like he was going to unzip his pants to relieve himself!! A real classic. After he was done taking a peek, I walked over to where he and Jose were standing looking at the trophies. Jason Robards had picked one up, when all of a sudden he dropped it. They were made of non-breakable products and there was the "HH" in the center. Well, the round centerpiece with the HH on it went rolling on the floor and we all laughed. It was so funny. Jason said, "Wow, what a cheap contrap-

tion; to think they give those to the winners!!" It was no academy award, that's for sure. I walked away after that leaving the backstage area and went outside to join the crowd of people entering the theater in their cabs and limousines. Entertainment Tonight was there to film the event and I saw Richard Kiley and Eva-Marie Saint get out of the limo and head into the theater. Then, among others, RoseMarie Harris, Barbara Cook, Robert Prosky, Anne Jackson, Art Buchwald, Eli Wallace, Richard Coe and Roy Dotrice all showed up. The stars were really out that night!!

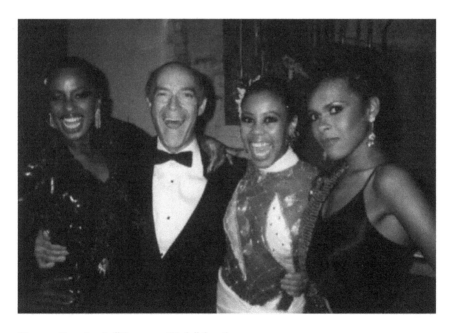

Keene Curtis & "Dream Girls" backstage.

Dennis Weaver & his wife.

CH. 3 - PREMIER OF 'THE SAMARITAN' WITH MARTIN SHEEN.

DOMINIC'S FRENCH RESTAURANT in Georgetown was hosting a dinner to the stars for the premier of Martin Sheen's movie "The Samaritan," which was a movie about Mitch Snyder's work with the homeless. I had two rolls of film and stood among the reporters and photographers clicking away with their cameras. As the stars started to fill the restaurant with the wives, dates, or daughters, I noticed Martin Sheen was alone. I realized everyone addressed him as "Marty," so

Martin Sheen & the author.

I did too. I told him as he passed by that it was nice to see him again and reminded him that I was one of the town folks hanging around Union Station when he and Cicely Tyson were filming earlier in the winter. I couldn't tell if he remembered me or not, but because he seemed to be alone, I asked him where his wife was. He said, "She's back home in California. She couldn't make it." So I suggested that I accompany him for dinner. He laughed and said. "I don't care, if they don't kick you out." I said, "Great! Let's go!" The restaurant was paying for everyone. Esther Rolle, and Stan Shaw and girlfriend, were seated at our table. We feasted on roast lamb and wine. Delicious! "Marty" spent a lot of time talking with Stan about certain celebrities who were too cheap and too selfish to make charity appearances. I looked around to see who was at the other tables and I saw Ned Beatty and

Ed Asner & the author.

his daughter enjoying themselves with Dennis Weaver and his wife. There were a few senators at the party, and Sargeant Shriver, Dick Gregory and his wife; all of whom I captured on film.

After the dinner party, everyone (including myself) piled into vans heading for the National Theater. I walked in with Marty, thanked him for his company, and then bid him farewell. I was on my own to watch the Premier. A late-night, open-air, and unguarded reception followed, during which I snapped many candid shots, including a hysterical photo of Dr. Spock (the baby doctor) with bread hanging from his lips as he munched away on a sandwich.

Entertainment Tonight, in filming the event, showed clips of the evening the following night on TV. My friends were all flabbergasted when they saw me on TV dining with the stars. They got a huge kick out of that. Most of my friends knew about my party crashing and each day would ask "What party did you crash last night?" Then I'd show them my photos so they could see for themselves.

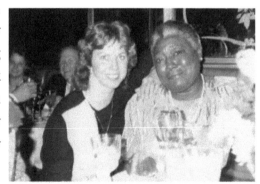

Esther Rolle & the author.

CH. 4 - POLO PARTY AT USDA BUILDING IN D.C.: SYLVESTER STALLONE

IT WAS A HOT SUMMER NIGHT and I heard that Sylvester Stallone and Brigitte (his wife then), and his brothers and father were going to attend a dinner party in the big hall of the Administration Building. He and Brigitte were at the Capitol Building earlier in the day to promote the Special Olympics and I overheard someone say they were going to the dinner party later that evening. Because I had worked at the South Building of USDA for three years, I knew all the doors of the adjacent buildings. I arrived one hour before the dinner (of course

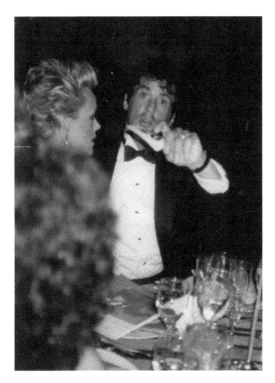

Stallone yelling, "Hey! Dat's enough!" at my continuous photo taking.

I had no pass or dinner ticket so I did what I do best) and went in the open kitchen door that was letting some of the steam and heat out for the cooks hard at work. As I walked in I smiled at them, they smiled back, and as usual, I exuded my "air of belonging" and headed into the ballroom area toward the tables where guests were gathering. I spotted Stallone with Brigitte and his father and started taking candid shots of them. I asked a woman standing nearby if she would take

my photo with them if they said O.K. She said she would, so I slowly walked over and asked Stallone if I could have a "real quick" photo with him and his wife and he said O.K. Later on, when he was seated at his table, I ticked him off because I was so excited I couldn't stop clicking and he grabbed his table number and said "Hey, Dat's enough!" Shortly after that I left. I was on a high because I had always wanted a photo of 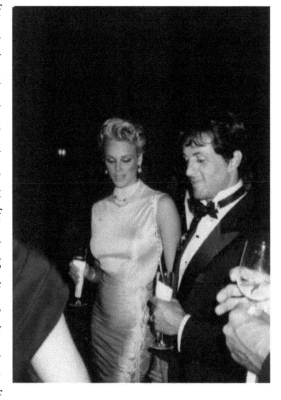 myself and "RAMBO" but never thought it would be possible.

About ten years later I had a chance meeting with him in Seattle where I got another photo when he was filming a movie. Such LUCK!!

CH. 5 - MARTIN LUTHER KING CELEBRATION

A BIG EVENT WAS BEING HELD on a Saturday night at the Kennedy Center to celebrate the Martin Luther King holiday. I went to the building early that afternoon and headed for a door that led to the stage area. I had been to this building before, so I knew the doors. Usually no one manned the doors because they were primarily used by office employees who worked on the second and third floors. As soon as I got off the elevator, I saw Stevie Wonder and his manager going into a room. I asked if I could get a fast photo with Stevie. They were both very nice and the manager snapped the photo for me. Stevie then autographed a record album for another guy standing by the elevator. Stevie was very sweet.

As I continued on through the corridor I noticed Debbie Allen. I

Celebrants on stage at the MLK Celebration, including Debbie Allen and Stevie Wonder.

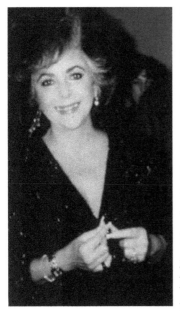

Liz Taylor.

stopped to chat and hopefully get a shot with her when Gregory Hines came up the stairs and I snapped a photo of him. As I didn't see any more stars, I decided to go home to get ready for the evening.

I returned at about 7:30 to find a man at the door. I smiled and walked slowly past him, trying to give the impression that I was an administrative person – it worked! I went straight to the sixth row in the auditorium so I could get some good photos of the finale. I saw Liz Taylor (looking smashing and trim); then the Pointer Sisters (who sang a song); and Winston Marsalis, and Lee Greenwood. Eddie Murphy, Stevie Wonder, Diana Ross, and some children came out and sang a song. Amy Grant, Michael Spinks, Peter, Paul and Mary, Quincy Jones, Patti LaBelle and the Blue Belles, were also there. I tried to get a photo with Liz Taylor but couldn't; her manager said she had to hurry and get ready for the show. I did get a nice photo of her alone that hangs in my living room. All in all, it was great. It seemed like everyone was there.

At the end of the show, all of the stars lined up along the stage. I got the funniest shot of Eddie Murphy wearing Stevie Wonder's sunglasses. Once outside, I tried to get another shot of Eddie Murphy but he had already split. I did see Michael Spinks standing around in his long, white fur coat. Like his broth-

The author & Quincy Jones.

er Leon, he has a pronounced gap between his teeth and in the photos I have of him he has his mouth closed.

The stars were on their way to a reception so I caught a cab to go there too. I tried to walk right in, but a woman stopped me and told me I couldn't. I told her that I was a photographer, but she said the "press" had to stay in a special area. I waited for a moment and when she left to greet a celebrity, I hustled straight into the event. Again, I saw Quincy Jones, Michael Spinks and Mary

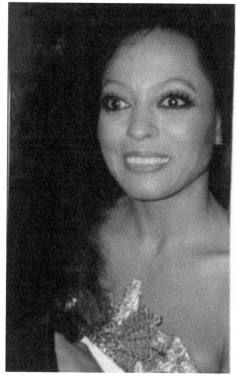

Diana Ross.

Travis (Peter, Paul and Mary). Mary was standing in line loading her plate with spareribs. I took photos of Amy Grant dancing with her

The author & Mary Travis
(from Peter, Paul & Mary)

manager and also got one shot of Amy and me together. I found Stevie Wonder again, eating at a table with his managers, so I snapped three more photos. Finally, his female manager said, "Lady, if you take one more photo, I'll take that camera away from you!" I decided I had taken enough photos for the night anyway, so I left. This was one of the best affairs I had been to in two years.

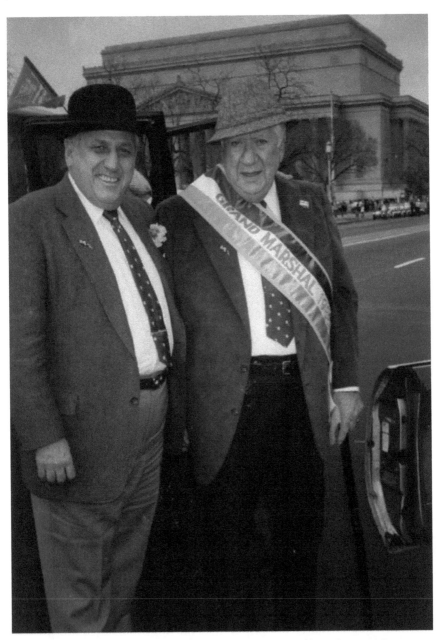

Tip O'Neill as Grand Marshall, with a friend, at the Cherry Blossom Parade in Washington, D.C., 1985.

CH. 6 - TIP O'NEILL'S BIRTHDAY

IN 1987 A PARTY was being thrown at the Hilton in D.C. for Tip O'Neill's birthday. As I walked through the lobby, I found an empty cocktail glass on a table. I picked it up, ducked into the ladies' room and filled it with water since it still had ice in it. I went out, smiled at the doorman, and entered the party. A big band was set up on the stage and there was a dance floor and a head table.

As I made my rounds through the room, I noticed a lot of photographers and reporters. I saw Albert, a photographer who attended many of the Embassy parties. When he saw me he said, "Michelle, I see you've made it in again!" He's the one who told me how to find the events and how to get by the guards. He invited me to sit at his table – that was great.

I excused myself to roam the room, where I found Cicely Tyson and Mrs. Walter Mondale. I took some lovely shots of Cicely, but the strange thing was that she wouldn't allow me to take shots of her straight-on. She prefers to be looking to the side to get profile shots only. She had put green hair spray in her hair to celebrate St. Patrick's day and the party. It looked festive. I also spotted Ted Kennedy and Bob Hope. I snapped photos of all of them. I did get some candid shots of

Tip O'Neill & the author.

Bob Hope talking with a woman wearing a low-cut dress. His eyes kept dropping to her bosom until she finally noticed and gathered her dress together so he couldn't get a glimpse of anything "important". Bob finally caught me stealing the moment and

Former President Gerald Ford & Bob Hope.

gave me a nasty look; again, captured on film.

Suddenly, someone tapped me on the shoulder. The woman asked me if I was a guest or a photographer and I said that I was a guest. She walked away a bit frustrated because she couldn't say anything to me if I was a paying guest, but I decided to go sit quietly with Albert. We had a filet mignon dinner, crisp salad, wine, and to-die-for dessert. It was quite a night!

Cheif Justice Warren Burger, Mrs. Bob Hope & Ted Kennedy Sr.

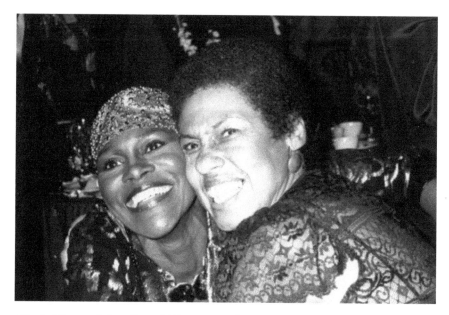

Cicely Tyson & her friend Eleanor Holmes Norton.

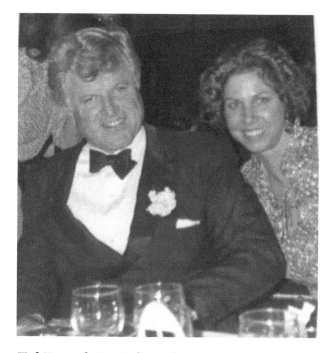

Ted Kennedy Sr. & the author.

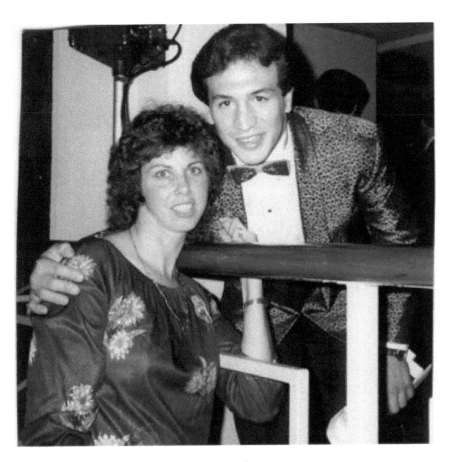

The author & boxer Ray "Boom-Boom" Mancini.

CH. 7 - ITALIAN-AMERICAN DINNER

I HAD NO IDEA WHO would be attending this event at the Hilton, but I decided to check it out anyway. When I got to the door, I told the clerk that I was to deliver photos to a fellow employee, which I did have in my bag. I also showed her my government badges. She told me that without a ticket, she couldn't let me in no matter what, but that if security wanted to let me in, that was their right. Sure enough they let me in, but not until they checked out my camera by looking in through the lens and pressing down the shutter to make sure there wasn't a bomb planted in it – I found it to be quite amusing, but they flagged me in. I did it again!

I was eager to see who would be attending and had a feeling that the President was expected because security wasn't usually that tight at these events. I found a table with four empty seats and asked the fellow seated there if I could join him. He said yes, so I used it as my perch to hunt for famous faces. I saw mainly senators and government people, and then suddenly the announcer said, "Ladies and gentlemen, Frank Sinatra and Mrs. Reagan!" Wow! I had never met Sinatra, so I snapped several shots of them. There was a roped off area about a block long lined with secret service agents sporting intimidating looks. Then the announcer said, "The President of the United States and Mrs. Sinatra!" Oh my God, he was there! The photos I shot of Nancy and Frank were fabulous conversation pieces later on when the earlier scandal of their "supposed" affair began to make the news. No one really knows the truth – but you know how rumors fly!

As I walked along the rope for 20 minutes taking pictures, I coaxed the Reagans to wave and smile. Finally, a secret service agent leaned over the rope and said, "Lady, I think you have enough photos for

now, can you please go sit down!" I did. We were served fresh baked rolls, salad, wine, broccoli, and baked salmon.

As speeches were being given, I noticed Boom Boom Mancini at a table – what a dreamboat. I had a guest take a photo of us together. Years earlier, he accidentally killed a Korean boxer during a fight, and it must have been very traumatic for him. Surprisingly, he asked me what I was doing after the party and said "Why don't you join me for a drink later?" I said, "Oh, I'd love to, but I'm going home to rest for a while and maybe I'll come back out after midnight." He gave me his number and said to call him. I said "O.K., Wow!, this would be great -- a chance to go out with a famous boxer." I left the party and caught a cab home, intending to take a quick nap, but didn't wake up until 6 a.m. Since I had to go to work that day, I thought, oh well, I wouldn't have been very good company anyway. I was tired and excited from the night's events, but the invitation was nice. He was so handsome.

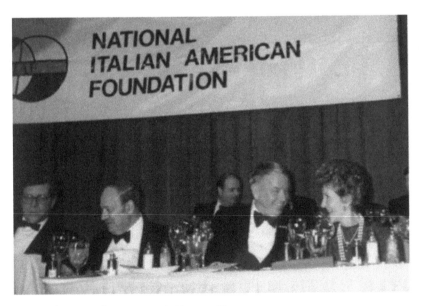

Far right: Frank Sinatra & Nancy Reagan.

CH. 8 - THE MARCH OF DIMES COOK-OFF

THIS YEAR THE COOK-OFF was being hosted at the Omni Shorham Hotel. It had always been a fun event and this year Willard Scott was scheduled to be there. I walked around and saw lots of news personalities from ABC and CBS cooking up some delicious dishes. I also

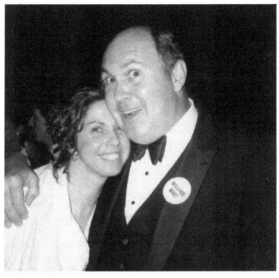

The author & Willard Scott.

saw Senator John Warner and John Lehman (Navy Secretary Head at the time) and Senator Hollings (he was so kind and funny, always laughing). Everyone was trying to win the prize for the best dish. The guests were able to go around and sample the food. It was great

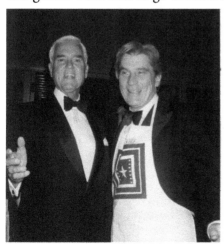

fun. But the highlight of the night was when I finally did see Willard Scott. He was wearing a pin that said "Willard Who?" He was so sweet and I asked a woman to take our photo together and Willard put his arm around me. I melted! He was so cuddly. This was a fun night.

Senator Ernest Hollings & Senator John Warner.

CH. 9 - BARRY GOLDWATER'S
RETIREMENT PARTY

IN 1986, BARRY GOLDWATER WAS GIVEN a retirement party one Sunday afternoon. I caught a bus to the Shorham Hotel and walked through the lobby and down the stairs to the ballroom entrance. There were five secret service agents spread out, and I saw the security detector machine leading into a smaller reception room. I thought I'd start there. I tried to ignore the first agent to my left and go through the machine at the entrance, but he caught me and said, "Excuse me ma'm, is your name on that list?" I said, "It must be." "Let's look," he said. So he guided me over to the guest book to look for my name. "It doesn't seem to be here," he said. I said, "There must be some mistake; a woman was supposed to call it in." "Well, she didn't, so I'm sorry, but you will have to leave. You may go back up that flight of stairs." And he pointed behind me. "Thanks anyway," I said. As I turned my back toward him and acted as if I was looking for something in my purse, he started to check another guest whose name was in the book. As he kept busy, I walked slowly backwards toward the security screen. Then another agent approached me and said, "May I help you?" I said, "Yes, that agent told me to go up the stairs." I pointed toward a different stairwell that led into the ballroom where the dinner was being held. He said, "O.K., but first go through the security screen and come out." Once inside, I saw ten or more secret service agents. Then I saw Barry Goldwater, his son, Claire Booth Luce with friends, and many other dignitaries. All of a sudden I saw the number two man of the country at that time: Vice President George H. Bush!

Oh my God! I was shaking like a leaf. I reminded myself to calm down and be cool. If I got hyper and excited now, I'd truly get kicked

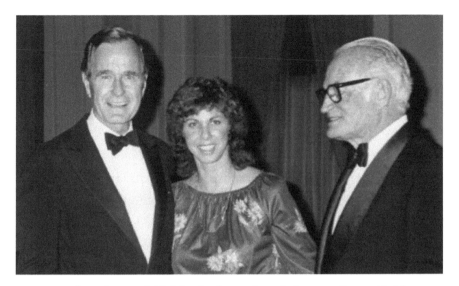

Vice President George H.W. Bush, the author & Senator Barry Goldwater.

out. So I walked up to a professional newspaper photographer (I really only had my camera, no film) and asked if I could get an extra roll of film because my "partner" never showed up with my supplies. He gave me a roll, and I thanked him. (The newspaper photographers always had extra rolls of film and I was on a low budget, so sometimes I would "borrow" film from them.)

That day I shot lots of candid photos of Bush talking with others. I finally got my nerve up and handed my camera to the generous photographer and asked him if he'd take a photo of George, Barry, and me, and he laughingly agreed. A woman was talking with George but I approached him and interrupted, "Mr. Bush, may I take a photo with you and Mr. Goldwater?" He exclaimed, "Sure!" as he and Barry closed in on me, putting their arms around me! My friends would never believe this. I was about to faint. The Vice President of the United States just put his arms around me! Years later, of course, he did become the President. I didn't stay for dinner; I got what I came for and was on cloud nine. No one was going to believe this one.

CH. 10 - NATIONAL THEATER:
CAROL CHANNING AND MARY MARTIN

IN 1986, THE PLAY "LEGENDS" was being performed at the National Theater in D.C., but I didn't hear about it until its closing day. Carol Channing, who was co-starring with Mary Martin in the play, was staying only two miles down the road from where I lived. I found out that the last show would be performed at 4:00 p.m. on Sunday afternoon. Of course I dropped everything and headed to the hotel one hour before the show to see if Carol Channing had left for the theater. I was in luck because she had not. When I walked into the lobby, the hotel manager and the banquet facility manager were standing there. I asked what time Ms. Channing was coming down, and they told me it would be about 15 minutes. I was allowed to stay for some photos as long as I stood to the side of the lobby. I noticed the banquet facilities manager starting to line up all her helpers in a long row – waiters, waitresses, bellhops, etc. – and they were just standing there empty-handed, getting ready to shake hands or say goodbye to Ms. Channing after a two-week stay. I thought it would be nice to give her flowers on her departure, so I looked around the lobby and noticed a huge (and I mean HUGE!) flower arrangement of fresh, long-stemmed red roses. I suggested to the manager that it would be nice to take a few roses from the arrangement and have each helper give one to Ms. Channing as she leaves. She said, "That would be great!" So she handed out roses to each attendant. Five minutes later Carol Channing and her husband exited from the elevator.

Carol was dressed in bright white; her trademark bright-red lipstick outlined way beyond her natural lip line, giving her the illusion of fuller lips. I couldn't help but think that she appeared clown-like, but she's done her makeup that way for years. Anyway, she smiled and shook hands with the hotel workers as they gave her the roses.

She graciously thanked them for their help and assistance during her stay. I took photos of her interaction with them as she walked out the front door. Then I quickly asked a passerby outside the main entrance to take my photo with her and her husband before they got into the white limousine. We took two photos together, which came out great. I then took a great close-up of Ms. Channing holding her flowers in the back of the limo with the door still open. After she departed, I thanked the passerby for his help.

I got into a cab and followed her to the National Theater, which was eight blocks away. I pulled up to the curb where lots of fans were standing at the entrance to the theater. They all swamped her, asking frantically for autographs, but her husband (a very distinguished man) got really (and I mean really) angry. He said, "For God's sakes, can't you people see we're late? Give the woman a break." And he grabbed her arm, pulling her away from her fans. As I watched this from the cab window, I knew then that the best opportunity for photos was at their hotel, away from other fans.

The author & Carol Channing.

Being at the theater where the fans bombard a star is not a place for pictures. No one wins that way.

I waited about 20 minutes and when the activity subsided, I walked to the stage door area, where a lady approached me and asked "Can I help you?" I said, "No, just picking something up from Harry, one of the stage hands." She looked puzzled and said "Oh." I smiled and continued walking past her. She probably didn't know the name of everyone who worked backstage so she didn't really question it. I went through another door to the auditorium, grabbed an empty seat, and watched the play.

It was funny, but raunchy. For two older female actresses, it was sort of nasty with a lot of foul language, but it was so amusing that I had to laugh and try to overlook the vulgarity. Most of the audience (which seemed to be made up mostly of people between their '60s and '80s) seemed to like it, but many people walked out early. As the show ended, I walked outside hoping for a few more photos, especially one of Mary Martin, who I didn't have yet. A theater manager came out and tried to push me and others off the sidewalk, saying we couldn't stand there. I said, "Yes I can, this is city property." This manager continued to argue with me and actually chased me into the street, and when she walked away, I hid behind a parked car and stayed there until Mary Martin walked out toward her limousine. Her chauffer saw me hiding and laughed. The theater manager held off the mob on the sidewalk to make room for Mary Martin as she stepped off the curb. I readied my camera and got two quick shots of her getting into the limo. I did it!

CH. 11 - PRESIDENT CORAZON AQUINO

I READ THAT PRESIDENT CORAZON AQUINO was in town for a few days and would be at the Madison Hotel in D.C. for a women's conference, so I headed to the hotel at about 6:00 p.m. I saw a long line of women winding down a spiral staircase from the second to the first floor. I proceeded to gently push my way past them up to the top until I got to the door where the guests were being checked in one by one. I saw a badge on the check-in table without a name on it, so I grabbed it, wrote my name on it and proceeded on in. Stepping in front of the lady next in line and smiling at the secret service agent, I walked through the door quickly. I continued pushing my way through the crowd so I could sit or kneel by the rope, closer to Aquino. She was already on stage giving her speech when I entered the packed room. I took a few photos of her and of those around her on stage. I hoped for a photo with her. After she finished her speech, she left the stage, and I tried to grab her hand to shake it and say hello. One of her guards grabbed my arm and said, "No! You can't do that!" while shaking his head and finger at me (they seemed a little more strict than the agents in D.C.). As soon as he was distracted with something else, I grabbed her hand and said, "Pleased to meet you Mrs. Aquino." She replied, "Pleased to meet you too!" She seemed so sweet and was such a petite woman. They whisked her out of the room immediately.

I left and prepared to be part of the town's farewell party on Sunday morning on the monument grounds to wave goodbye. She pulled up in a government car and headed to a helicopter waiting to take her to Andrew's Air Force Base. She waved to everyone below on the ground. What an exciting weekend!

CH. 12 - PRINCESS DIANA

IN 1985, PRINCESS DIANA AND PRINCE CHARLES paid a week-long visit to D.C. Their schedule appeared in the Washington Post, and I planned my course to possibly get a close glimpse of them. Taking photos with them is an impossible feat due to royal rules and regulations, but that's one rule I'd love to break.

The first day they were making public appearances. Prince Charles was scheduled to go to a function without Diana in Virginia, while Di and Mrs. Bush were to go to a hospice for the terminally ill in NW Washington. It was a pleasant Saturday afternoon and I caught a bus to the location. I had my USDA badge and an old driver's license with a hole punched in it that I could put a chain through and hang around my neck (to make myself look "official" if no one looked too closely). As I got close to the nursing home, I saw the huge crowd of neighborhood people and curiosity-seekers standing across the street in a yellow-tagged, roped off area.

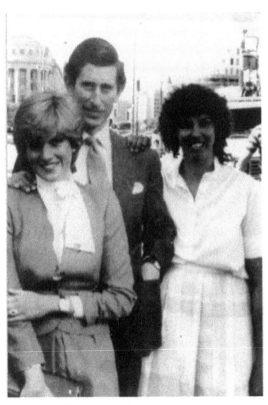

The only "faux" in the collection: Princess Di, Prince Charles & the author.

Mrs. George H.W. Bush, a hospice worker & Princess Diana at a Washington, D.C. hospice in 1985.

There were many police on guard. As I walked slowly toward the sidewalk closest to the care facility, I avoided looking the police directly in the eye. I looked toward the building and got near the walkway. I had two IDs around my neck, hoping they'd swing back and forth as I walked so the police would see them and two cameras on my shoulder. I tried to look as "newsy" as possible. I caught a glance of one policeman's eyes but kept walking up to the press area where photographers and TV camera crews were set up. I went under the rope and sat on the grass near all the news people and didn't move for an hour. I was excited, as well as nervous.

As the limo pulled up, Princess Diana and Mrs. Bush got out and were greeted by Mary Massarini from the State Department, who escorted them inside. I took a few photos of Di getting out of the limousine and a few standing alongside Mrs. Bush. Diana was wearing a conservative red dress and seemed so shy, holding her head down and occasionally turning her eyes and smiling at the press twenty feet away. It was awesome. My mouth dropped open as I watched the scene. I had taken photos of Queen Elizabeth when she was in Seattle in 1984, but I never thought I would get to photograph Princess Diana in my lifetime.

I left the area after shooting one roll of film and checked the paper to see where the royal couple would be next. They were scheduled to be at the Washington Cathedral the next day. When I arrived, I walked up to the back side of the Cathedral to a roped-off area, and as usual, tried to ignore the few police at the bottom of the grassy area. As I continued to walk up the walkway a policeman yelled out, "Excuse me, ma'm. Where are you headed?" I answered, "Up to the media area." I had noticed a small roped-off area on the grassy hill near the Cathedral steps where at least 50 photographers were standing. He said, "O.K., but see my Captain first when you approach

the top of the hill." So as I got closer to the media area, sure enough a policeman with "Captain" on his badge approached me and said, "Can I help you?" I said, "Oh, no. I'm just going to the media area to get some photos." He asked if I had ID. I showed him my government security badge and my driver's license and he looked me in the face and said, "Well, okay, but stay inside the roped-off area." He was pretty lenient. I'm thinking, everyone and their mother works for the federal government in Washington, D.C., so any employee could have mixed in with the media to get close-up photos of the couple arriving for church services that day if they tried. But in D.C. no one tries that I guess. Just Michelle (smile).

When the royal couple finally arrived, everyone started clicking and snapping away with their cameras. Princess Diana waived to the crowd again. All of a sudden a strong gust of wind blew her black and white hat off her head. It went flying through the air. Someone caught it and returned it to her. It was a comical sight. As she and Prince Charles walked up the stairs to enter the Cathedral, she turned around one last time and waved again. What a day! Later, at 4:00 p.m., she and Charles went on a tour of one of the Smithsonian Museums, but the tourist crowd was so bad down there I couldn't get close to anyone. However, I had enough photos from the weekend. On my way home I noticed a man on the sidewalk with black and white cutouts of Charles and Diana. For $5.00 he would photograph you with them. I thought what the heck, it's the closest I'll ever get to them (looking like I was standing next to them). It actually looks real. I took the Polaroid print home and had a negative made. I made more copies and told my friends it was real. It's my only faux in the collection of about 400 photographs.

CH. 13 - EMBASSY STORIES

I passed the British Embassy on a Sunday afternoon and noticed a party in progress in the garden area. I thought "Oh! A party! I'd love to see if I could get in." There were five ladies entering the gate to the gardens where the host was checking them in. I parked my car up the street and grabbed my camera. I had just come from church.

As I approached the gate, the last woman went through, and I proceeded to go in right behind her. The gentleman said, "Excuse me, do you have your invitation?" I said, "Oh, I believe I left it in my kitchen." He said, "Well, I really need to have it." I told him that I was on a free-lance photo assignment and would only need one hour. I also added that if he needed the invitation that badly, I would just go home and get it later. He wasn't too confident about that, but when I produced my government ID (a/k/a "press pass"), he told me to go ahead.

I proceeded to the back yard of the embassy, which seemed as large as a football field. In the rear of the embassy was the whole garden party in motion. Women were wearing the most spectacular dresses and creative summer hats, and the little girls accompanying the women were adorable. The many fruits, vegetables, and luncheon entrees looked delicious. The party was catered by Ridgewell Caterers, of course. (They did the catering for all the political and celebrity functions in D.C.) However, after two years of their sandwiches, meats, and fancy foods I actually started to get tired of the same (free) dishes and desserts. This is not to say the food and displays were not impeccable – they were. It all just got to be old after a while. Hey! There's just no pleasing some people, right?

As I wandered around the garden taking a few photos of the guests there, I met the Ambassador and his personal guests. I overheard

The author & Christopher Plummer.

someone saying his children were in town from California and swimming in the Embassy pool on the other side of the garden. I headed over there and found a cute little boy and girl swimming in the pool. I took a few photos of them and then, in spite of being somewhat tired of the typical catered fare, I went back to have a few beverages and a sandwich, and to mingle with the guests. There were some older women dining with their young handsome men dressed in tuxedos. I figured out from reports about the party set that these men were not their grandsons, but rather paid escorts to accompany the women. They stood in their dignified manner by the sides of their dates like loyal little puppies. It definitely made me chuckle.

Just as I was about to take a bite of food, I felt a sharp swat across my back. I turned around to see the Ambassador's wife staring at me with a pink parasol in her hand. She said, "There my dear, you've just

49

been debugged." I guess I had a spider that had fallen from a tree on the back of my dress; so I thanked her and laughed disbelievingly. I couldn't believe I was getting "beat up" by the Ambassador's wife.

Naturally, I began a conversation with her. She told me how her grandchildren rode their big-wheel bikes up and down the corridors of the main floor of the Embassy in the evening and how their toys were scattered everywhere. "They are little angels," she said, "but it's always nice when your relatives go home and all is quiet again." I agreed and short-

Mrs. Charlton Heston, Michael York, the author & Mrs. Michael York.

ly thereafter excused myself. I wandered close to the open doors of the Embassy and when no one was looking, took a self-guided tour of the main floor's living and dining areas. The floor was marble, and there was a big-wheel bike parked near the wall. I took a photo; it seemed so out of place. I planned to tell anyone who asked, that I was searching for the restroom if I were to get caught inside, but I managed to walk back out before anyone saw me. I saw that there wasn't a soul on the main floor and briefly thought about going upstairs to see the bedrooms, but I decided not to invade their privacy any further. I did overstay my one hour limit, but became friendly with the Ambassador's wife and she was nice enough to invite me back later in the evening to take a few photos of some Hollywood stars who

planned to be there for dinner before going to a Shakespeare Festival in Virginia. Of course this time I got the invitation and left my name for a return later that evening.

I went home to change and rest for awhile and when I returned at 7:00 p.m., the guards graciously passed me through when they looked up my name. I entered the reception area on the main floor and saw Helen Hayes. I had seen her at several other events I had crashed and she was now a familiar face. I really loved her; she was such a pleasant person. She often had her most-loved male companion by her side, as she did now, but I never learned his name.

I took a few candid shots of her visiting with the guests and then I saw Christopher Plummer. He had cut his ear while shaving (I assume) and kept grabbing at the white band-aid on it. He was overly suntanned and not very pleasant. He may have been tired and looked rather grouchy. I handed my camera to a lady guest standing near me and asked her to snap a quick photo of Christopher and myself, but when I approached him, he mumbled something and turned sideways toward the crowd. I told her to go ahead and take the photo with him near me anyway so I could add it to my collection.

As I entered another room, more guests were standing around drinking cocktails. I first spotted Michael York and his wife. They are a surprisingly short couple – he's so debonair and she's a beautiful blond. They let me take a photo with them and their guests. And then, along came Charlton Heston and his wife. What a dashing couple. I got a few photos of them too. Finally, I excused myself from the party. They truly did invite the Hollywood set.

Entering the Japanese Embassy was like trying to enter Fort Knox. Truthfully, I never was able to get inside more than the main lobby. So, I missed out on an event that looked "ritzy and glitzy" from the outside. C'est la vie.

I made up for that loss by getting into the Indonesian Embassy. It seemed a bit bizarre and gaudy inside. There were really exotic marble animals and sculpted figures dotting the hall and Indonesian paintings on the walls. When I arrived at the door, I smiled and signed my name to the guest list and enjoyed the free food and drinks. (Yes, it was that simple.) The food emitted a pungent scent and since I'm not familiar with Indonesian food, some of it tasted a bit odd to me. Of course, I was able to admire the fancy attire of the women, but the men donned the same generic black tuxedos.

One night I was able to enter the Israel Embassy. My God, what tight security they had! I saw a man standing near the door with what looked like a Uzi machine gun, and all guests were required to enter through the security screen. I wondered if this was a reflection of the turmoil they have been experiencing in their homeland for years. I signed a guest book and mingled with the guests but didn't stay long. I ate, drank and left (quickly). The guns made me uneasy.

On another beautiful evening I decided to attend a party at the Brazilian Embassy. When I arrived, I saw a crowd gathered at the doorway; there were photographers, reporters, and guests. I tried to avoid the woman who was checking in the guests and to gently nudge my way through to the main party area. Suddenly she touched my shoulder and asked, "May I help you?" I thought, Oh Lord, I'm caught, but I said, "My name is Michelle LeClech and I'm here on assignment for the Post." She said, "I don't know, we already have five photographers here." As she turned back to see if I should be admitted, I moseyed on in through the crowd of about 500 people and wandered down to the lower courtyard.

Next to the fabulous feast arranged on the table, I saw a man who turned out to be then President Sarney of Brazil. I asked a woman to capture the moment of us together. She did, but his wife seemed

shocked and surprised at my boldness. (Can you imagine?) I demurely inched away from them after the photo was taken.

I found my way to the bar and asked the bartender for my favorite party-time drink: rum and coke. Then I picked up a plate and tried a sampling of the tiny sandwiches and desserts. From my seat, I watched the men in their tuxedos and women in their glamorous sequined gowns wander about and mingle. I introduced myself to a woman sitting next to me, but we did not engage in lengthy conversation. I did ask her if there were any special politicians or celebrities in attendance. She told me that John James of "The Colby's" (remember that TV show?) and Pele' (soccer legend) were upstairs.

Of course, I went upstairs and approached John, who happened to be surrounded by women. When I asked him if I could photograph him, the women momentarily parted so I could get him alone on film. Then his beautiful girlfriend emerged from the flirting crowd and I snapped some shots of them together. In turn, his girlfriend was nice enough to take a photo of me and John together. He had a smooth style and seemed down-to-earth. I thanked them and continued to hunt for Pele'.

As I made my way through the crowd of partying people, I noticed another small group huddling around someone. It was Pele'! I patiently waited for a chance to talk to him and he agreed to a quick photo session, at which time I asked a woman to do the honors. As I was about to leave, John James showed up and Pele' requested a photo with him. Needless to say, I obliged. Pele' then gave me his address and asked me to mail the photo to his home in New York, which I did.

As the evening continued, I grew tired and decided to head home. Another successful party had been added to my history!

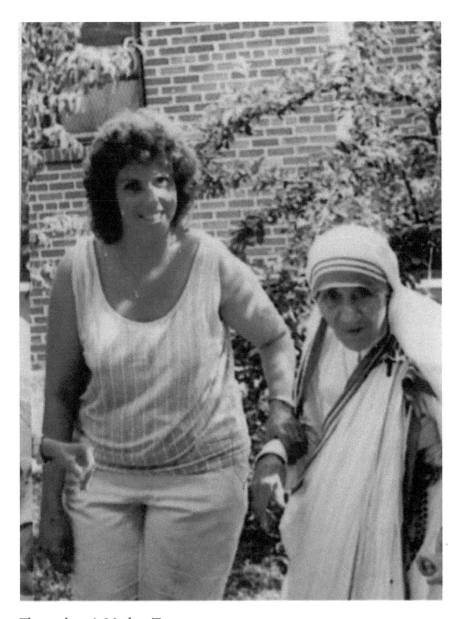

The author & Mother Teresa.

CH. 14 - MOTHER TERESA

IN 1986, MOTHER TERESA DEDICATED a soup kitchen to the needy people in SE Washington, D.C. I was working at the Washington Navy Yard as a secretary at the time. I had made many friends throughout the Navy Yard in my job there and one day a friend and co-worker, Jeannie, approached me and said, "Michelle, I know you like to take pictures of famous people. How'd you like to meet Mother Teresa?" My response was, "What? Mother Teresa in Washington!?" She said, "Yes, but some priests will give the mass for the dedication and Mother Teresa will give a speech. The nuns will run the food kitchen to feed the needy." She went on to tell me she knew about the event and that she volunteers her time to help the nuns who live there. To me, it was the thrill of my lifetime. Mother Teresa had already been called the "Living Saint" among the Catholics and is a past Nobel Peace Prize recipient. Now I would be able to add someone as noble as her to my collection.

When Jeannie picked me up that Saturday, we went to the soup kitchen 30 minutes before the mass was to start. It was 80 degrees out and very humid. We parked the car and walked up the stairs leading to the kitchen, which was located next door to the convent. Some of the sisters, including Mother Teresa, walked out. I couldn't believe she was only 20 feet away! Senator Mark Hatfield of Oregon was standing with his aide near the front porch and they were talking to her. So I snapped a few candid shots of them, which I later sent to his office. He returned the favor with a thank you note, saying that they would put a 5x7 copy in the Mark Hatfield Library at Willamette College in Oregon. I felt honored. But as he finished his conversation, I walked toward Mother Teresa and gently touched her arm, and walked alongside her. I had Jeannie take a photo of me walking with her toward the soup kitchen before everyone piled into

the kitchen area. Men, women and children from the neighborhood, and volunteers who helped Mother Teresa were present. About 100 people were crammed into the eating area. Some were sitting cross-legged on the floor, others were standing around the back and sides of the room, and I knelt in the doorway so as not to block anyone's view.

As five priests dressed in white were about to give a mass, I began snapping away. I captured shots of the priests and Mother Teresa sitting among the little children of SE Washington. The children stood up, danced, and sang a cute song for Mother Teresa as she watched and laughed. She then delivered her speech asking people to love one another, to pray for the sick and the handicapped of the world, and to pray to the Mother Mary for peace. Unfortunately, I forgot to monitor how many photos I had taken, and at this sacred moment my

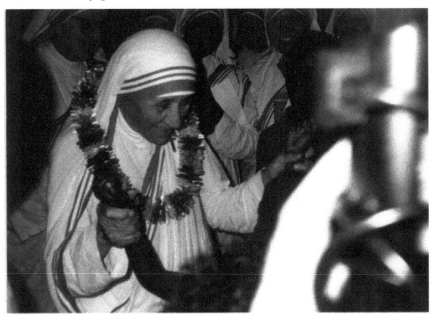

Mother Teresa does a little dance with one of the children in attendance.

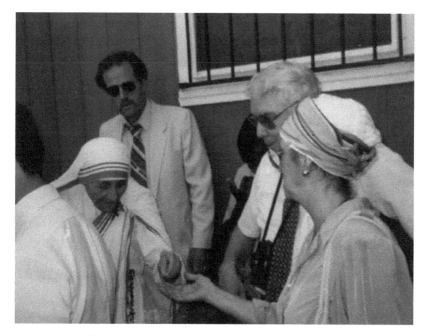

Handing out "little religious medals" to those in attendance.

camera began to noisily and automatically rewind. Everyone turned around in my direction with disgusted looks, not to mention that the sound of the camera drowned out the words of Mother Teresa's speech! How embarrassing. I ducked into the kitchen until the rewind was completed and then went out to reclaim my space. I did refrain from snapping any more photos until the mass ended. Since it was so hot and humid inside, everyone filed out into the cool shade of evening. Outside, Mother Teresa lined up the people in attendance as she passed out religious medals and kissed each one. I still couldn't believe that I was in the presence of a "living saint". When she finished, she looked very tired and told everyone she was going to retire for the evening. Everyone waved their tearful goodbyes. The experience of being in her presence will forever remain with me. As she turned to go up the stairs, I wanted a touch of holiness, so I touched her feet. I walked away hoping something really special

would happen in the future. Why not? Life is full of miracles.

A miracle did occur in my life: my son. I was told I may never be able to have kids because of past female problems but after meeting and touching her feet (like I've seen other people do on tv in the world who met her and her holiness,) I conceived a son the next year.(of course I had a man in my life but never thought I'd be blessed enough to have children.). Meeting her and Princess Diana in Washinton,,D.C. was probably the highlight of my life after meeting so many famous people.

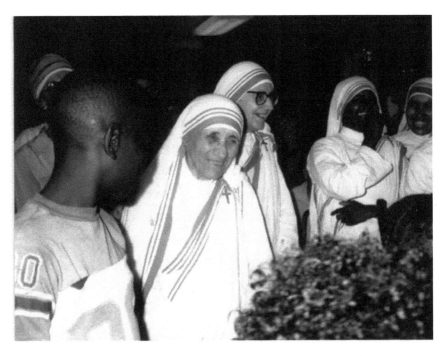

Mother Teresa & her nuns have a lighthearted moment before Mass & the Dedication of the soup kitchen in southeast Washington, D.C.

CH. 15 - MUHAMMAD ALI

ODDLY ENOUGH, I MET MR. ALI many times while I was in D.C. So many, in fact, that I started to consider him a "buddy" and decided that I should attend his appreciation night held in Seattle (where I was living at the time). Any loyal friend would do the same, don't you think? So, during the day I made my trip to the Sheraton Hotel to learn the floor plan. I checked out the reception room which had a marvelous view of Lake Union. But, more importantly, I learned where the door was to access the kitchen and, coincidently, found that it was right next to the elevator. That was my ticket to the party!

In the evening, I returned sporting my elegant evening wear. There were several people chatting in the lobby, so I stopped to visit with them. I told them about my "hobby." They were amused by my stories, so I told them that tonight I would be looking for an empty seat at a large table. They laughed and said that they would see me inside.

I went around to the kitchen from the hallway, and, yes, the door was unlocked! I passed unnoticed through the kitchen (the crew was being schooled on etiquette) and out the door into the reception room. At that point, I waved to June and her guests – I knew them from the local church. Soon after, the couple from the lobby entered the reception. They laughed when they saw me seated at a table. "What a riot! You did get in!" they said. "Of course, it works every time," I replied.

There were many important guests seated at the table, but before I could take note of whom they were, the great Muhammad Ali entered the room. After he acknowledged the audience with a wave, I walked right up to him for a photograph. I already had many photos of Ali, but I just needed one more. He agreed to the photo and it turned out well. After taking enough photos of the affair, I exited to the lobby where I spotted Ken Norton! This was my chance to add to

my collection of great boxers, so I recruited a nice man in the lobby to snap the photo. Near the end of the dinner, I left on another high. What a nice party and it was good seeing the boxers again.

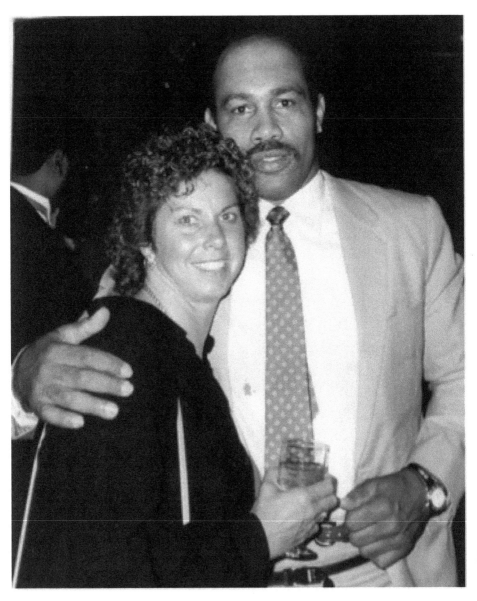

The author & boxer Ken Norton.

CH. 16 - SUGAR RAY LEONARD'S
BIRTHDAY DINNER

BOXING IS, AS YOU MAY HAVE GUESSED, my favorite sport. If I ever meet a single, fanatical boxing fan, I'll marry him on the spot. As I was working for the USDA, I used my department badge and the fib that I was taking photos for the Ag Reporter to crash the affair, which was being held in the beautiful lobby of the USDA building. I was so excited to check out the action at this one!

My first "victim" was Floyd Patterson, who was sitting at the end of a table looking bored. Then I noticed Robert Guillaume and Don King (sporting his funny hairdo). Someone took a picture of us together while I

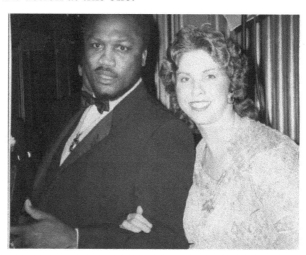

Joe Frazier & the author.

continued to search the room for other notable guests. I spotted: Vanessa Williams, Hector Camacho (a very cute middle-weight boxer from Mexico), Sugar Ray with his wife and two sons, Stokely Carmichael, and Cicely Tyson. Cicely and Stokely seemed happy to see each other and asked if I would take their picture and then forward it to them. They gave me their addresses. Mr. Ali entered shortly thereafter and I got a few shots of us together and also one with Carmicheal. I snapped some photos with Joe and Mavis Frazier (who ran a limousine service in Chicago, until Joe's death in 2014). He was quite a flirt, inviting me to come see him sometime – yeah right!

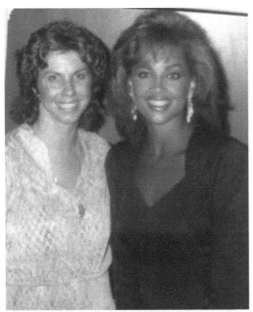

I couldn't believe the number of celebrities and boxers who were present in the room, all "dressed to the nines" as they said "back in the day". It was wild! Throughout the evening though everyone kept asking, "Where's Tyson? Anyone seen Tyson?"

Left: with Vanessa Williams. Below: the author & Vernon Jordan.

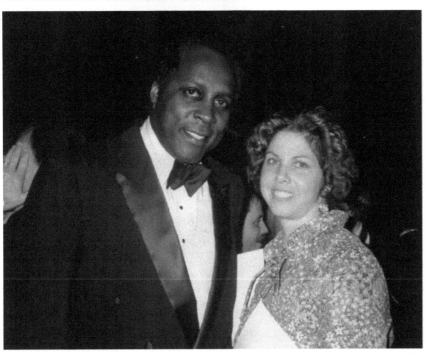

Don King.

Robert Guillaume & the author.

The author & Charlie Rose.

CH. 17 - RUDOLPH NUREYOV

"THE KING AND I" WAS PLAYING at the Paramount Theater in Seattle. One night I waited by the side stage door one hour before the show was to begin. Rudolph finally arrived and I asked to take a quick photo of him. A stagehand took the photograph of us together. I thanked him for the photo and autograph as he ducked into the building – he was a man of few words.

I really wanted to see the play, but didn't have the $30.00 for a ticket, so an open side door that led to the theater was my ticket in. I stepped right in and grabbed an empty seat close to the exit and hoped that I wouldn't get thrown out. The play was fantastic. After the show, I waited by the stage door again to snap a few more frames of the world's grandest ballet dancer!

The author & dancer Rudolph Nureyov.

CH. 18 - PAUL McCARTNEY

I NEVER DID GET TO MEET PAUL, but on the night of his rehearsal at the now-imploded Kingdome in Seattle as I waited outside, his limousine drove by and he rolled down the window and said, "Hi guys!" and then zoomed into the Kingdome.

I got into his concert by telling the overwhelmed clerk at the door that I was there to take photos for "the children's hospital" and that I had to hurry so I could meet my assignment to get pictures during the first two songs. As I pushed my way in while at the same time rattling off my story, he didn't have time to argue. I waived to him and kept going. I navigated my way to the front with my two cameras hanging from my shoulder and I stood on top of the usher's chair for five minutes to take pictures. I watched the concert for about 30 minutes and left – it was a fun concert.

CH. 19 - HIGH SCHOOL ACHIEVEMENT AWARDS

I HAD READ ABOUT THE high school achievement award ceremony that was to be held at the Marriot in Washington, D.C. with several celebrities scheduled to attend. When I arrived, the young man at the reception area noticed my government badge dangling from my neck and told me that the "press" had to enter at the side door. I did. I was in.

The affair was done up in elegant decorations and the room was full of people. I spotted Muhammad Ali, Loretta Lynn, and John Johnson (publisher of Jet and Ebony magazines). There was also Bo Jackson sitting at a table. Then I noticed William Simon, the ex-energy czar of the early 1970s sitting with Steven Spielberg! I took a few photos of them and then Steven Spielberg posed for a photo with me. He framed my face with his hands and I opened my mouth really wide to be funny – it was. I didn't stay for dinner since I had already had a productive evening.

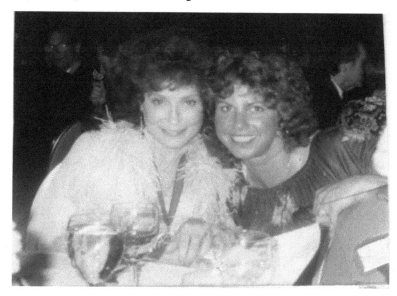

Loretta Lynn & the author.

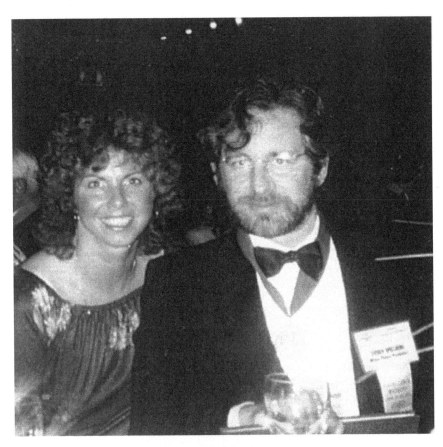

Above: the author
& Stephen Spielberg.
Right: the author &
Muhammad Ali.

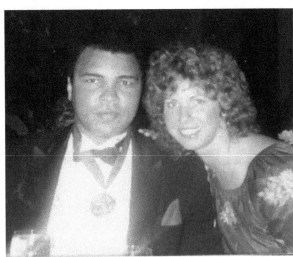

CH. 20 - GEORGETOWN RESTAURANT PARTY
WITH PETER JENNINGS
WASHINGTON, D.C.

ONE EVENING A DINNER PARTY was scheduled for the grand open-
ing of the Potomac Restaurant on the Potomac River in Georgetown.
Peter Jennings and other news personalities and dignitaries were to
attend. It was an unusual dining atmosphere. Because the front en-
trance looked like it would be difficult to enter, I walked around to
the courtyard entrance. Basically, I stepped over a low-chain fence
to join the party. I walked by the front desk and into the dining area.
The ceiling was covered with colored glass and non-conventional
chandeliers. There were enormous lobsters on display and wine
glasses stacked up into a pyramid on the table. It was extremely hot
inside, so I decided to go back outside for fresh air. And, who did I
see? Peter Jennings! I had my photo taken with him immediately.
He was so handsome. He asked me what the style of dress was inside
the party and I told him it was the usual tuxedos and evening wear af-
fair. He was very upset to hear that because he was wearing a regular
dress suit; but I assured him that he looked striking and that people
would expect to see him dressed in his trademark "news" suit. He
calmed down.

Then I saw David Brinkley sitting at a table with a pretty blonde
woman. Even though he was eating he agreed to a photo, so he me-
thodically placed his knife and fork on the table and posed for the
photo. I didn't ask him for more since he seemed a bit grumpy – just
like on TV.

As I continued to roam about, I saw Liz Taylor's ex-husband, John
Warner, with a young woman eating dinner. I stole a candid shot of

them and then proceeded to ask him who his lady friend was. He replied, "If you don't already know, then I'm not telling you – you don't need to know!" I thought, well, excuse the heck out of me, and walked away.

On my way out I was shocked to see a photographer I recognized from the Washington Post, walking to his car with one of the huge lobster claws bobbing up and down from his suit pocket. It was a crack-up – and I thought "I" had nerve!

Peter Jennings & the author in Washington, D.C.

CH. 21 - ODDS & ENDS, PT. 1

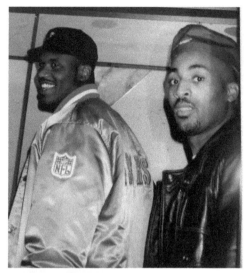

*Right: Shaquille O'Neal and
a friend.*
Below: President Nixon.

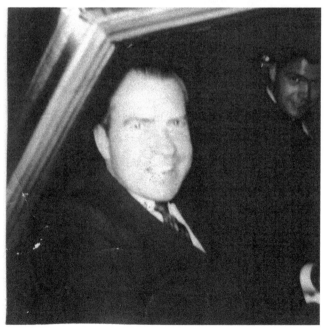

The "Rainbow Lady" was a colorful Seattle icon.

Right: the author &
Ken Griffey, Jr.
Below: the author &
Michelle Rodriguez.

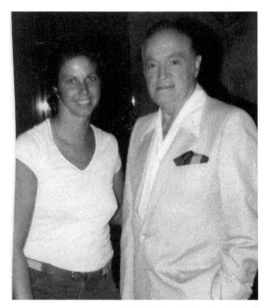

*Left: the author &
Bob Hope.
Below: President Clinton
& the author at the
Edgewater Inn in Seattle.*

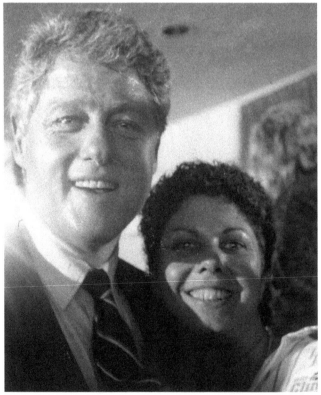

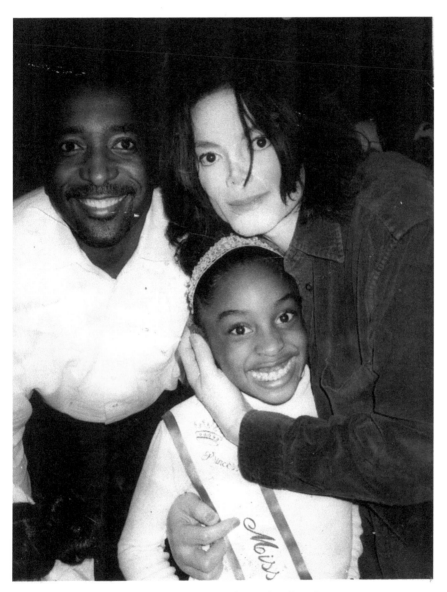

A friend's husband and daughter with Michael Jackson.

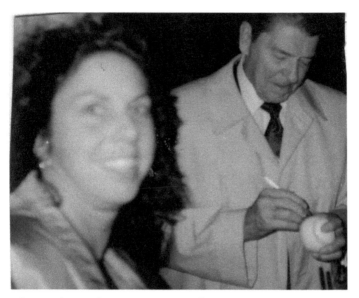

Above: the author next to President Reagan.

Below: Vincent Price.

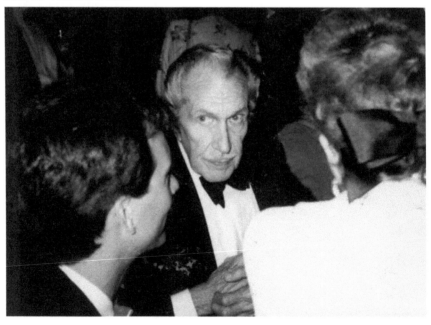

CH. 22 - BILL COSBY

I WAS VISITING IN D.C. IN 1988 when I heard that Bill Cosby would be attending a fundraiser for Jesse Jackson. I caught a cab to the Hilton and saw a small group of people waiting for the door to open. I walked past them and about 50 feet away, low and behold, it was the door leading to the ballroom. It was open for fresh air. I walked in and saw three waitresses finishing the final setup. There was also a committee of about five men talking in a group with Bill Cosby. I watched them for a moment and noticed a woman asking him for an autograph. He was ignoring her, trying to finish his meeting with his colleagues, but she was persistent. He finally obliged, so I took the opportunity to ask for a photo. I asked a man if he would take a photo of me standing behind Bill. When he shot that one, I asked him to get one of Bill and me

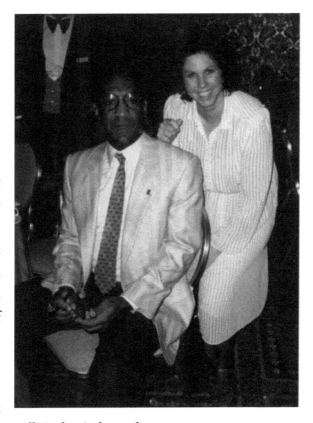

Bill Cosby & the author.

together. He said, "I will if he will let you." I asked Bill and he said with a frustrated look, "OK, but please do it quickly, I need to finish my meeting." We took one more, but he didn't look too thrilled about having to pose with me in the photo. As I began to leave, the same woman started pestering him for more autographs. She asked, "While we're at it, can I have three more autographs for three more grandchildren?" He didn't give her the autographs, but he did give her looks that could kill. She crept away. It was a bit funny. On my way out, I bumped into his wife Camille – she is a beautiful woman, so I took her photograph too.

CH. 23 - JIMMY CARTER

When I lived in Washington, D.C., I lived only seven blocks from the White House. Jimmy Carter was president that year, and I was always tempted to go to work late so I could snap a picture of his daughter Amy being escorted to school by the secret service agents. I never did.

It wasn't until 1990, when Carter was in Seattle for a book signing that I got to meet him. He wrote a book on hunting and fishing. I happened to be talking to the receptionist of KIRO TV when Jimmy Carter walked in. I had no idea what he was doing there and unfortunately I didn't have my camera with me. There were a few high school kids touring the studio that day, so one of the boys who had a camera took a picture of Jimmy and me together. I sent him $5.00 for the shot and the kid sent it to me – it came out great.

I found out that Former President Carter would be signing books at the Elliott Bay Book Store in Seattle's Pioneer Square area, so I headed on down that night with my camera. I wanted another photo of him (I'm greedy). He was busy signing books and told me he didn't have time for a photo with me, so I asked someone standing in line to take the shot with me behind him anyway. It was amusing because he's looking down at the book. He wouldn't look up for the photo. He may have recognized me from earlier in the day.

I didn't want to give up and when I glanced down at the floor, I saw a food stamp with USDA printed on it. So I thought, "Jimmy Carter/peanuts—my old job at the USDA" and dashed back to the table where he was signing. I pushed the stamp across the table, hoping for an autograph, and thinking it was funny. He finally looked up at me with a disgusted look and shoved it back at me. Apparently

he didn't get my sense of humor and wouldn't give me his autograph. He was all business that evening.

Two weeks later, I saw an old Native-American man who asked me, "Hey Lady, hey, you know what I think of Jimmy Carter?" I said, "No, what?" He opened his hand and a little peanut sat in his palm. Ironic, don't you think? I never laughed so hard in all my life.

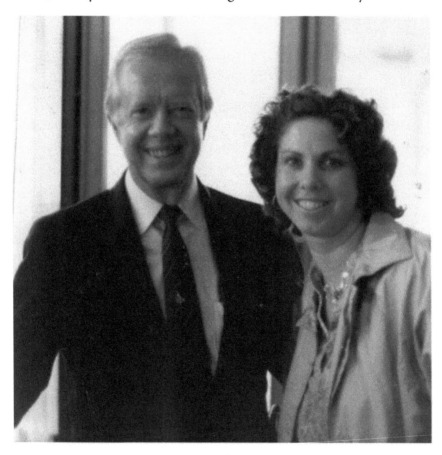

Former President Jimmy Carter & the author.

CH. 24 - MADONNA

IN THE '80s, I took a friend with me to the Madonna concert at the Kingdome in Seattle. We got there 20 minutes before the show was over, so when we were stopped at the entrance, I quickly told the door crew that I was a photographer and had to return for my equipment. Strangely enough, he just waived us in. I didn't hope to get any photos with her because there were thousands of fans, but my friend and I managed to move through the crowd until we were in front of the stage. I was able to get some excellent shots of her wearing a wild short red dress. Her show was raunchy, but brilliantly choreographed. We walked out with the crowd at the end of the show. What an entertaining night; even if I only got in for the last 20 minutes!

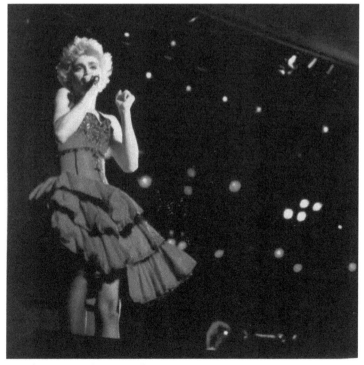

Madonna at the Kingdome.

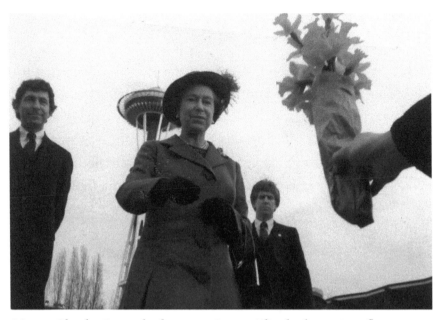

Mayor Charles Royer looks on as Queen Elizabeth receives flowers during her visit to Seattle in 1984.

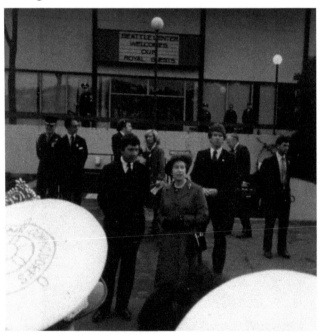

Mayor Charles Royer showing the Queen around Seattle Center.

CH. 25 - QUEEN ELIZABETH AND PRINCE PHILIP OF ENGLAND

IN 1984, I HAD JUST RETURNED to Seattle from Europe when I learned the news that Queen Elizabeth would be in town. What irony: I had just left Buckingham Palace, where the Queen was nowhere in sight, but when I returned home, I found out she was coming here to Seattle!

I hurried to Boeing Field and stood with the large crowd to wave to her as she entered her limousine after leaving the plane she had just arrived on. I caught up with her later at the Seattle Center and snapped a few photos of the Queen and Prince Philip. I was very excited. Too excited, in fact, because as I was pushing and dodging my way quickly through the crowd, a secret service agent came from behind, pulled me up in the air by my coat, and flung me backwards into three old women who were sitting quietly in their seats until I knocked them onto the ground. It was a bit embarrassing and all I could do was apologize. Thankfully, he didn't take my camera so

I was able to re-enter the crowd from another angle and finish my photo session with the Queen. I got a beautiful shot of the Mayor, the Queen, and a little girl who handed her a bouquet of yellow daffodils. Well, I learned a valuable lesson that day: Do not move like lightning through a crowd, you'll blow it! I came away with some great photos and lots of bruises on my shoulders. I hoped the ladies I was shoved into were O.K.

The Queen & the Mayor.

CH. 26 - KING HUSSAIN OF JORDAN

In 1986, I was taking my usual Saturday morning stroll around Georgetown, a neighborhood in Washington, D.C., to see who I could see. I came across a roped-off area and some police cars parked at the side entrance of a hotel. I was told that King Hussain and his wife were about to arrive for a breakfast meeting. I had my camera in my backpack, so I walked into the lobby to find yet another roped-off area, where no one was allowed to enter.

I stood about 30 feet away from the couple as they passed. His wife was a beautiful blonde American woman from D.C. I snapped some great photos as they entered the elevator. As you can see, I have quite a collection of Presidents, Vice Presidents, Kings, Queens, Princes, and Princesses.

CH. 27 - 1990 GOODWILL GAMES

WHAT FUN I HAD at the Goodwill Games in Seattle! I attended the opening and closing ceremonies and the entire week of boxing matches. I met a few of the Puerto Rican boxers and decided to take them out on the town. It was a blast. On the weekend of Seattle's famous Seafair events, I escorted them to the colorful Torchlight Parade and then we went to the Space Needle. The manager of the Space Needle allowed us to take the elevator to the top, at no cost because I told him that we were broke and that the guys were athletes at the games. It was a warm, gorgeous evening, and I even ended up seeing Jane Fonda and Ted Turner.

At the closing ceremonies on the following Sunday, I was with my son, Denis (who was about three at the time). I took his picture sitting on Jane Fonda's lap and another one of him hugging Quincy Jones.

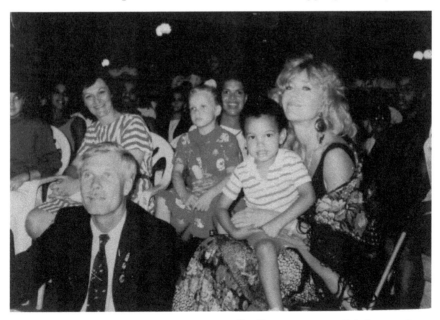

Front row: Ted Turner, my son Denis "DJ" on Jane Fonda's lap at the opening ceremony & speeches at Westlake Center in Seattle.

Ted Turner & Jane Fonda.

I also got some photos with Tevin Campbell and an invitation from one of the volunteers to attend a Friday evening dinner for the boxers who would be leaving. It was to include the boxers from the many different countries, their friends, and some celebrities. Denis played with all the other children there, and I dined on salmon, halibut, gourmet salads, and wine. There was also outdoor dancing by the bay.

I made many friends. Victor, the Soviet's coach, gave me a beautiful scarf and address book from the Soviet Union. The Korean and Bulgarian teams gave me their country's pins. In exchange for the gifts, I gave them ringside photos of their boxing matches. I was even able to get the 1972 Olympic Gold Medalist Ray Seals up close and on film. What a great time was had by all.

CH. 28 - JACKIE CHAN AND DANNY GLOVER IN SEATTLE

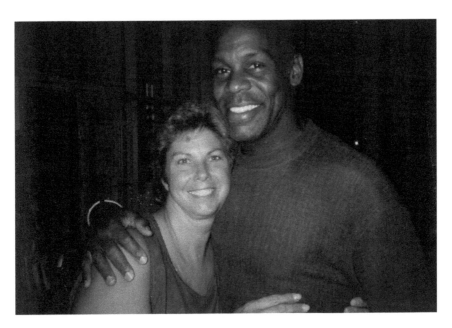

The author & Danny Glover.

IN 1998, JACKIE CHAN was at one of Seattle's Costco stores promoting a book he had written. There was a huge crowd and the line for autographs seemed never-ending. But, what I wanted was to try and get a quick photo with him. I asked a guy in line if I could slip by him for a moment to talk to security and he let me. Hoping for his sympathy, I made up a "sick relative" story. That story was repeated to Jackie Chan, who nodded his head and smiled and I had the security guy take our photo while Jackie put his arm around me. I thanked him and left quickly on an unbelievable high.

On the same day, Danny Glover was also in town. He was giving a speech from the balcony of the Westlake Center in Seattle. His message was to kids, telling them to stay in school and study hard, and

that they could get ahead in life easier if they did. I didn't stay below with the crowd on the street. My son, Denis, and I went into the Center and up the stairs to the second floor and waited patiently by a wall until Danny Glover finished his speech and came inside. Then we asked him if he would pose with each of us for one quick photo. He was real nice and said "Sure!" We thanked him and left on a high again.

Jackie Chan & the author.

CH. 29 - SOUTH AFRICAN PRESIDENT NELSON MANDELA, SEATTLE, 1999

I ALWAYS DREAMED of getting a photo of Nelson Mandela and myself to add to my collection because I had always heard so much about him through the years, but never thought it possible. Then I found out he was going to be in Seattle at various places (after he retired from the Presidency) for speeches on freedom and equality. One of the locations was to be at a South Seattle daycare. My son had a dental appointment that day near there and we thought we'd swing by and park the car near there and see if we could get a peek at him. There was so much security and police that I figured if I wasn't lucky enough to get a photo with him I thought maybe my 12-year old son would. I went into my "little

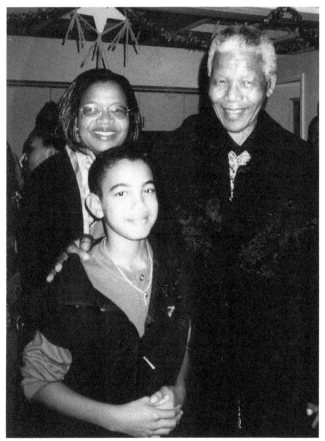

My son Denis with Nelson Mandela & his wife at a daycare in Rainier Valley, Seattle, 1999.

white lie mode" again and told a female police officer I wanted to go inside the daycare center so my son who "had an incurable disease" could see or meet Mandela, as a dream come true. (Actually, he didn't even know who he was at the time. I had to tell him how famous he was!) She felt sorry for us and asked someone and they said O.K., come in and stand by the wall near the reporters (television and newspaper coverage). When Mandela entered the room he started talking to my son and asked his name and age and said "What do you want to do when you grow up?" My son said, "Be a famous baseball player!" Mandela laughed and said, "and after that?" And my son said, "Oh, after that, I'll retire!" Mandela and his wife and all the people in the room just roared. The cameras flashed and the television cameras were rolling and everyone had a good time. Then he patted my son on the head and said, "Good luck." Then Mandela proceeded to go sit down for his interview with the daycare people. Well, I didn't succeed in getting a photo with him myself, but I was very excited to have one of my son with Nelson Mandela. That was a dream-come-true. What a day! We left the building and several reporters surrounded my son to get the spelling of his name and ask how he felt meeting Mandela. The photo was in the local newspapers and my son was on the news the next day shaking Nelson Mandela's hand. This "eccentric hobby" of mine is so much fun. Being in a crowd has always given me an adrenaline rush.

CH. 30 - ANN LANDERS

ANN LANDERS WAS IN SEATTLE for a women's conference. I called the major hotels to find out where she was staying, and it turned out to be the Sheraton. When I was put through to her room she said, "Hello" in a gentle voice. I said, "Hello, Miss Landers. I'm Michelle LeClech and I was wondering what time you planned to come down for your 8:00 conference." She graciously told me that she would be down at 7:15 and that she wouldn't mind doing a photo session. She came down with a friend, who took our picture. It was a thrill to meet her.

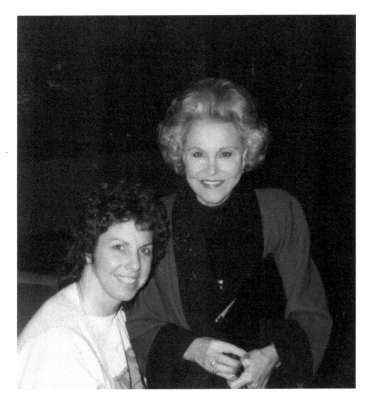

The author & Ann Landers.

CH. 31 - JESSE JACKSON

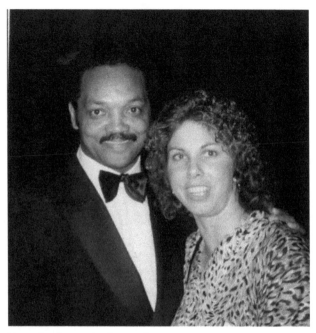

Jesse Jackson & the author.

I HAD GOTTEN PHOTOS of Jesse Jackson at various rallies in Washington, D.C. in the '70s and also at the Kennedy Center, but I first saw him when a friend and I were at a restaurant for lunch in 1974. We strolled over to his table to talk to him and he asked me my name. I told him and he said, "Nice to meet you, Miss Michelle." As the conversation went on, he repeatedly called me "Miss Michelle" in that southern hospitality tone. I saw him again several times, the last being at the Kennedy Center for the Martin Luther King ceremony. He always seemed to be the "Man About Town" in D.C. in those days.

CH. 32 - H. ROSS PEROT

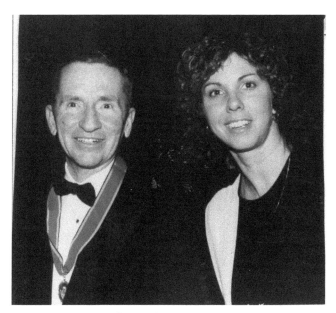

H. Ross Perot & the author.

IN 1986, I WAS AT THE Omni Shorham Hotel checking out another party. It was almost over when I arrived, so I asked someone if there was anyone famous in the crowd and a lady said, "Well, if you call H. Ross Perot famous, I guess I'd say he's the only one here." Because I didn't have my camera that day, I asked the main photographer there to take a photo of us. He did and later sent it to me. Now the photo I have of Perot means even more to me due to his on-again/off-again 1992 presidential campaign odyssey.

CH. 33 - FORMER PRESIDENT GEORGE H. BUSH

SO WE MEET AGAIN! George H. Bush was in Seattle at the Sheraton for a meeting. I pulled my usual stunt of badge swapping. One of the guests left the rally before Bush was to make his appearance. I picked up the badge from the table, put it on, and walked toward the ballroom. I smiled at the doorkeeper and went in. I had brought three copies of my photograph of Bush and myself which was taken in 1985. I hoped that he'd come around to shake hands with the crowd before leaving the room. I planned that instead of shaking hands I'd pull out my photos of us and quickly and politely ask him to autograph them. That might make the photos more valuable. My plan worked. He signed all three! I left the room on yet another high.

CH. 34 - DIRECTORS' CONVENTION

IN JUNE OF 1992 the Directors' Convention was held at the Seattle Sheraton and Convention Center, where I camped out for three days. I was lucky enough to get a quick photo session with Maury Povich and Phil Donahue, and I was also fortunate enough to get into a meeting that Whoopi Goldberg was attending and got a photo with her. I knew she was scheduled to attend three functions that day and I noticed she was wearing a solid black outfit. I asked her if she would be wearing the same outfit to all of the functions and she replied, "Honey, once I put the shit on, it stays on the rest of the night!" That's Whoopi for ya!!

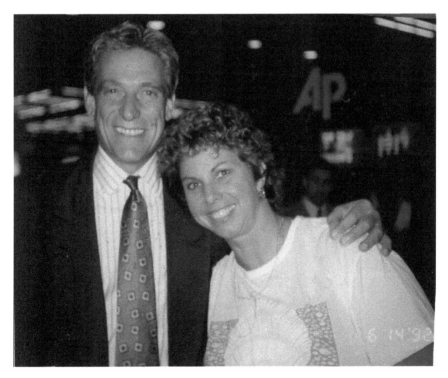

Maury Povich & the author.

The author & Whoopi Goldberg.

Phil Donohue & the author.

CH. 35 - GERALDINE FERRARO

GERALDINE FERRARO WAS VISITING the Westin Hotel in Seattle to speak to an audience. I rode the elevator up to the ballroom to find it filled already, and they weren't letting anymore people in. Ferraro wasn't there yet, so I figured she had to be in one of the little rooms in the hallway. I started going in and out of all the rooms, when all of a sudden a Secret Service Agent grabbed my arm and asked, "What are you doing?" I said "I'm looking for Ms. Ferraro to get a quick photo." He was actually nicer than most secret service agents and said, "If you sit quietly on this bench, she will be passing by shortly." I said "O.K." and thanked him. He was right: she came out from a door only 15 feet in front of me, so I stood up and when she got close to me I asked her if I could take a quick photo of her. (I didn't ask

for one "with" her because they were ushering her by me so quickly.) She said, "I'll do better than that, you can take one with me!" as she handed my camera to one of the secret service guys. I didn't believe she was doing this, and from the look on the agent's face, he seemed incredulous as well. He did snap the photo but gave me a dirty look as I smiled, took back my camera, and walked away. I liked her style – brazen, like me, so they say.

The author & Geraldine Ferraro.

CH. 36 - MICKEY ROONEY

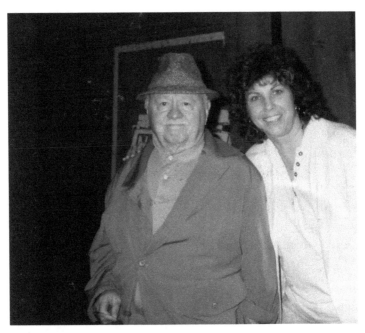

Mickey Rooney & the author.

MICKEY ROONEY WAS IN SEATTLE to be in a play at the Paramount Theater so I went an hour early to try to get a photo with him before he got out of his car to go in the side stage door. I had brought my 4 year old son with me and a friend to take the photo, should we get lucky. Sure enough, here he was, he got out of the limousine and I walked calmly up to him and asked if he would take a quick photo with me and my son and he said "sure!" He was short and real sweet – one of America's greatest movie stars!!

CH. 37 - JOHNNY MATHIS

I'VE ALWAYS LOVED THE MUSIC of Johnny Mathis and collected his albums when I was in my teens. When I found out he was coming to Seattle in 2005, I knew I just had to go see him. I got to the theater a few hours early to see if maybe he was practicing. I noticed a .café at the theater with the door open, so I walked in and ignored the people dining there and walked into the lobby and stood by the door to the auditorium and there he was practicing. He had jeans on and a blue shirt and didn't have the band practicing with him. I watched and listened for about 20 minutes and also noticed a few stage hands getting photos with him before he finished practicing. I left then, counting on my luck to get a photo with him after the show, which I'm usually able to do. On this occasion I actually bought a ticket so I'd be sure to have a seat. For show time he changed into 3 or 4 different outfits – it was a great show. When the show was over, I went out to the side of the theater where I had gotten celebrity photos in the past. I thought this would be my "photo op" when he comes out of the stage door. So many people started gathering there after the show (with the same idea) that when his bodyguards started to escort him outside and saw the crowd, they retreated inside and closed the garage door. I then assumed they would probably put him in the SUV I'd seen and head for his hotel. I had my next plan of action ready. I ran to my car parked a block away and drove to the side of the theater where I watched and waited. After 5 or 10 minutes went by the garage door opened and the SUV moved out slowly onto the street and I pulled out right behind it and followed them a couple of blocks when it quickly turned into an alley by a hotel. They escorted Johnny Mathis into the lobby of the hotel, and I, meanwhile, pulled up right behind the SUV, grabbed my camera, got out and left the door wide open with the engine running.

(I didn't care if someone stole my car.) I just wanted the photo with Johnny Mathis. There were only two guys in the lobby asking him to sign their old record albums.

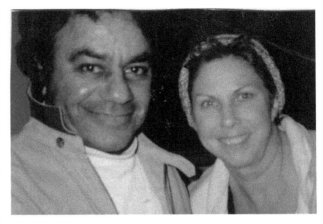

Johnny Mathis & the author.

(They must have known he was staying there.) Since there wasn't a crowd, he signed for them and then I asked him if I could have a photo with him real quick. He said "O.K., you don't want an autograph?" I said "No, I want a photo with you. I've waited all my life to see you in person!" He looked puzzled but said "O.K." and let a guy take the photo of us together. I was in seventh heaven! What a night!

CH. 38 - DIAHANN CARROLL IN TACOMA, WASHINGTON AT THE ANNUAL SUSAN G. KOMEN BENEFIT FOUNDATION LUNCHEON

IN 2002, I WAS DIAGNOSED with breast cancer and was going through chemotherapy. The nurses at the hospital knew the Susan G. Komen Foundation was having their annual benefit luncheon at the Sheraton Hotel in Tacoma, Washington and they were nice enough to acquire free tickets for some of the patients to go. They said the celebrity speaker was to be Diahann Carroll. I thought "Oh great! Maybe I'll get my photo with her too" to add to my collection. It was a nice buffet lunch with around 400 in attendance. Elisa Jaffe was there from Channel 4 TV and Jean Enerson from KING 5 TV. What fun and witty speakers they were. Then Diahann Carroll spoke. I said to myself "I'll wait until it's over and people start to leave." I worked my way slowly to the front and waited until she talked with five or six other people, and then I asked a lady standing next to me if she would take my photo if Diahann Carroll said O.K. and the lady agreed. So as I approached Ms. Carroll, I noticed she had these big horn-rimmed glasses on. I usually get my celebs to "take off their glasses so their beautiful eyes can show through." When I reached her I asked her if I could take a quick photo with her and she said O.K.! And then I asked her if she would take off her glasses so I could see "her beautiful eyes." But she looked at me and said "no, I don't want to!" and I said "O.K." So, the lady with my camera took the picture, as is. I got my camera back and thanked both women. I continued to stay at a short distance, still watching Ms. Carroll. I was fascinated because she is an ICON among the beautiful Black female movie stars. By this time, other people were posing for photos with her too, and then she finally took off her glasses for one of them so I quickly snapped

another photo of the four of them. It came out nice and I was right, she did have "beautiful eyes!" What a nice time I had mingling with other women going though the same hardships as I was. I'm fine now, Thank God.

Diahann Carroll & the author.

CH. 39 - STEVEN SEAGAL
IN SEATTLE, WASHINGTON (MAY 2006)

I READ IN THE NEWSPAPER that he had a blues band called the "Steven Seagal Blues Band" and that they were going to be playing at a local tavern on Saturday. So I drove there four hours early and waited in front in my car thinking he'd come in the front way as his band was already there waiting for him, but as I started to look through the locked door I heard the band start playing and he was already inside with them. He had entered through an alley on a tour bus two blocks away that I didn't know about. He played a guitar and he and a lady sang together. I asked someone how to get to the back of the building and they told me how to go around. I waited another hour until he was done practicing and as he was headed out of the back of the tavern he was going into the bus for a rest with his wife and daughter and brother in law. I asked his brother in law to ask him if he'd come out

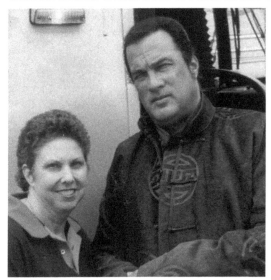

The author & Steven Seagal.

and take a photo with me real quick and he said wait for 20 minutes as they had a meeting and he'd ask him. I said O.K. After 20 minutes the guy came out and let me come in the gate and stand by the door to the bus and all of a sudden out stepped Steven Seagal smiling and grinning but sort of shy. He said nothing but stood there,

arms folded and I stood next to him. He was so tall and handsome! One of the guys took my camera and took the photo of us together. I was in Seventh Heaven! I couldn't believe it. What a night! Another guy outside the gate wanted a photo with him too, but they only let me come in. What a thrill! I thanked him and left on a high note! That was worth the five hour wait!

CH. 40 - ODDS & ENDS, PT. 2

Above: Chuck Norris & the author.
Right: the author & Frankie Avalon.

Liberace with the author's mother & sister in Seattle.

Above: the grave of Bruce Lee and his son, Brandon.
Below: Carol Channing receiving roses from her staff.

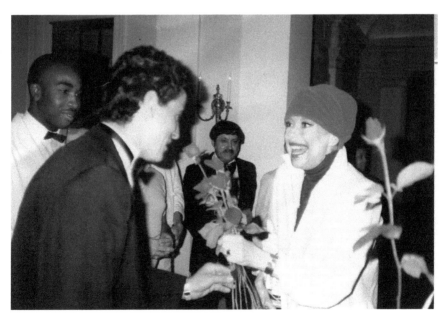

Above: Stephanie Powers, the author & Robert Wagner.
Below: Mrs. Warren Burger and Bob Hope (giving the author "dirty looks" for getting carried away with "the photo taking")

Left: Sig Hansen, Crab House Captain on the Discovery Channel, & a fan in Seattle. Below: Oprah Winfrey at the Opera House in Seattle.

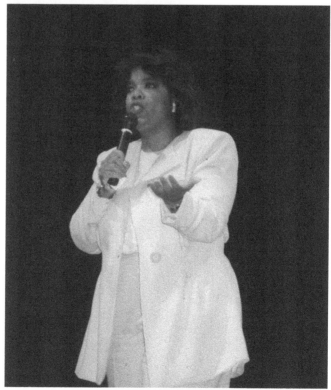

CH. 41 - INTERNATIONAL NAVAL REVIEW
IN NEW YORK HARBOR, JULY 4, 1986
ON U.S.S. IOWA

ON THE 4TH OF JULY IN 1986, the best place to be to celebrate was New York. I was working for the Navy at that point and thought that I should hitch a ride on a boat set to sail for the harbor so I could get the best view of the fireworks. When I arrived in New York at the Greyhound bus station for the weekend I saw two guys from the Navy band. They told me they were in town to play on the USS Iowa. Wow! I asked them if I could come and they said to meet them at the dock the next morning.

We had to ride a smaller boat to a larger boat, so it was there that I ran into the other Navy men I knew. They were shocked and asked, "What are you doing here?" I told them I was out to have fun on a boat today. The guys let me travel on the small boat with them, but I had to agree to go back to land if they couldn't get me onto the Iowa. Once on the water, I saw Walter Cronkite in the boat ahead of us! We also found out that President Reagan had just departed the Iowa. I was so excited, and as I climbed up the ladder to get on board, I prayed. At the top of the ladder, there were two sailors on both sides of the entrance saluting people as they arrived. When I got to the top, I smiled and said, "I'm with the band!" The sailor said, "Well, then, you'll have to wear this," as he handed me a visitor's pass. I never thought I actually would hitch a ride on a U.S. Naval Aircraft Carrier!

On board, the tables were over-flowing with beer, corn on the cob, and the largest BBQ ribs I've ever seen. I was talking to a sailor sitting next to me when I spotted Walter Cronkite and his wife. I told the sailor who he was and suggested that we give up our seats to him and his wife, since there were none available. After they accepted

our seats, I snapped their picture, and, unfortunately, everyone else finally realized who they were also. I guess my telling several people who they were didn't help either. Because of the crowd surrounding them they were unable to eat until someone rescued them by asking everyone to give them some space. The fireworks and the hundreds of boats in the harbor were spectacular. I'll never forget that day.

CH. 42 - THE FISH THAT GOT AWAY

WHEN I WORKED AT THE Department of Energy in 1973, I missed a photo opportunity with Vice President Ford and myself because I had used my last shot on Mr. John Sawhill (Assistant Energy Czar). I also missed Zsa Zsa Gabor who was attending a dog show because I opted for the Goldwater retirement party on the other side of town.

Once I attempted to visit the Universal Studio in LA with my son. It took us four hours on five buses from the airport to the studio which is only a 20 mile trip. On the final shuttle to the studios, I met Diane who said she was on the TV show "Northern Exposure." I just assumed she was an extra because I didn't recognize her. I told her our story about the 4-hour, 5-bus trip to the studio and she felt bad. She asked us to come with her, and at the gate she told the clerk she was our friend and we got in for half price. She also took a photo of me and my son. I didn't, however, think to have her join us. Later I found out she played "Barbara", the female police officer who appeared in some episodes! Well, I missed a star and a nice one at that – maybe I'll catch her in Redmond, Washington sometime.

But the most important one to me, the one who has been the most elusive, is Tom Selleck. If anyone out there can help me out, please invite me to the party!!

About the Author

MICHELLE LECLECH HAS BEEN taking photos since a kindly old neighbor lady put a camera in her hands,at age 11 and she has been clicking ever since. First of neighbor kids then school friends then rock stars and as she got older and read the teen magazines all the time she wanted to meet famous people and get photos of and with them as a hobby. She moved to Washington, D.C. from Seattle after she graduated from high school. She read the newspaper daily looking for all the fundraisers coming to town with celebrities in town and planned her course each day or evening to get in the best way she could.

CPSIA information can be obtained
at www.ICGtesting.com
Printed in the USA
BVHW021737290819
556997BV00003B/3/P